Francis Bacon

Francis Bacon

Sam Hunter

Photographic Credits:

Astrup Fearnley Musset for Moderne Kunst, Oslo (pp. 86-87); Cecil Beaton (cover); Des Moines Art Center, Iowa (p. 11); Detroit Institute of Arts (p. 20); Fondation Beyeler, Riehen/Basel (pp. 23, 35, 45, 80-81); Fundación Thyssen-Bornemisza, Madrid (p. 54); Hirshhrorn Museum and Sculpture Garden, Smithsonian Institution, Washington (pp. 72-73); John Deakin (p. 6); Kunsthaus, Zurich (pp. 28-29); Kunsthalle, Hamburg (p. 51); Ludwig Museum, Cologne (p. 39); Moderna Museet, Stockholm (pp. 52-53); Musée National d'Art Moderne, Centre Georges Pompidou, Paris (pp. 55, 65); Museum of Modern Art, New York (p. 38); Nationalgalerie, Berlin (pp. 31, 43); Solomon R. Guggenheim Museum, New York (pp. 12-13); Stedelijk Museum, Amsterdam (p. 48); Tate Gallery, London (pp. 8-9, 19, 76-77, 90-91); Tehran Museum of Contemporary Art (pp. 68-69).

© of this edition: 2009 Ediciones Polígrafa, S. A.
Balmes, 54. 08007 Barcelona (Spain)
www.edicionespoligrafa.com

Of the images: © The Estate of Francis Bacon, VEGAP, Barcelona 2009

© of the photographs, texts, and translations: the authors

Coordination: Montse Holgado
Text: Sam Hunter
Notes on Works: José María Faerna
Translation: Wayne Finke (Notes on Works)
Copy editing: Hend Bautista
Design: makingbooks / Salvador Bocharán
Color separation: Estudi Polígrafa / Annel Biu
Printing and binding: Nexográfico, Valencia

Available in USA and Canada through D.A.P./Distributed Art Publishers
155 Sixth Avenue, 2nd Floor, New York, N.Y. 10013
Tel. (212) 627-1999 Fax: (212) 627-9484

ISBN: 978-84-343-1202-9
Dep. legal: B. 675 - 2009 (Printed in Spain)

Contents

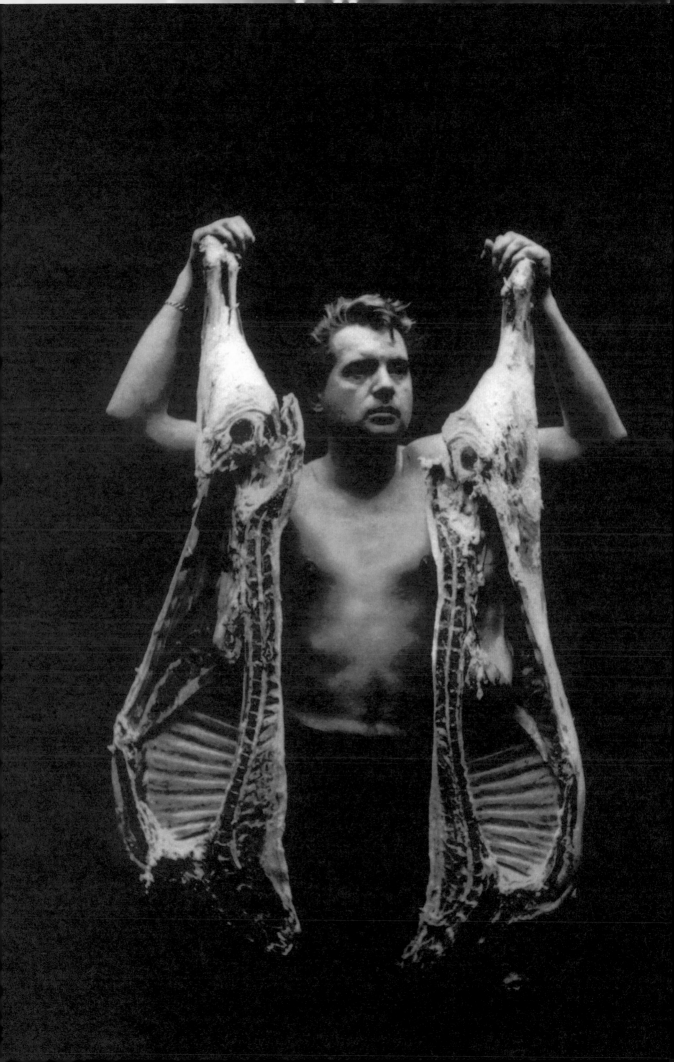

Sam Hunter Metaphor and Meaning in Francis Bacon

The paintings of Francis Bacon have been the object of a good deal of critical
confusion and loose, romantic appreciation over the years. They have rarely
encouraged a consensus of informed opinion or a systematic objective analysis,
with the notable exception of the recent monograph by Hugh Davies and Sally
Yard and a controversial study of Bacon's iconography by the art historian of
Surrealism Dawn Ades (whose conclusions, however, the artist disavowed).[1]
Bacon cannot be readily categorized as an artist who fits neatly the traditional
stylistic distinctions or matches the identities that have so often been reserved for
him, among them, a hallucinatory realism and specialized aspects of Surrealism
and Expressionism. He has been perceived, at least by the casual public, as a
sensational trafficker in obscenely horrific imagery of the mutilated human form,
which in turn generates an association with some of the more distressing
historical episodes of the 20th century and with the plight of the individual today
who has, at least in contemporary literature, experienced life as basically "absurd."
To the further dismay of his less knowing viewers, his visual assaults on taboo
subject matter and conventional taste have, if anything, been made even less
palatable by his wild, baroque extravagance of style and the transparent
emulation of the Old Masters in their painterly technique and even their formal
presentation. Ironically, his insistent glazing and use of resplendent traditional
picture frames helped intensify some of his most horrifying subject matter and
chimerical effects. Bacon feels that by segregating his sinister and inciting
imagery behind a glass barrier, the effect of surface unity can be enhanced
without compelling him to reduce either the visual candor of his representation
or the abruptness of its oppositions.

What became increasingly clear with the test of time, as Bacon entered his
eighties, was the clarity, durability, and powerful authority of his visual discourse.
The issues at the center of his highly individualistic art necessarily involve an
amalgam of widely diverse topics, contemporary and historical, drawing on a
variety of formal explorations and visual sources—from photography and
popular culture to the didactic uses of the past, from a deliberate iconography of
tragic implication to a furtively impressionistic, a historical pictorial method
based on impulse and chance. All his strategies are enriched by the conscious
play of psychological and philosophical metaphors touching on some of the
most fertile paradoxes of modern thought.

The early interpreters of Francis Bacon's work emphasized its potent, original
imagery and violent content at a time when a new humanist figuration, with
distinct overtones of existential angst, had begun to appear in postwar art.[2] Other

• • •

1 Hugh Davies and Sally Yard, *Francis Bacon* (New York: Abbeville, 1986); Dawn Ades, "Web of Images," in *Francis Bacon,* exhibition catalogue (London: Tate Gallery and Thames and Hudson, 1985; New York: Abrams, 1985).

2 Sam Hunter, "Francis Bacon: The Anatomy of Horror," *Magazine of Art* 45 (January 1952): p. 5; Robert Melville, "Francis Bacon," *Horizon* 20 (December 1949-January 1950): pp. 419-23; James Thrall Soby, "Mr. Francis Bacon," *Saturday Review* 36 (November 1953): pp. 48-49.

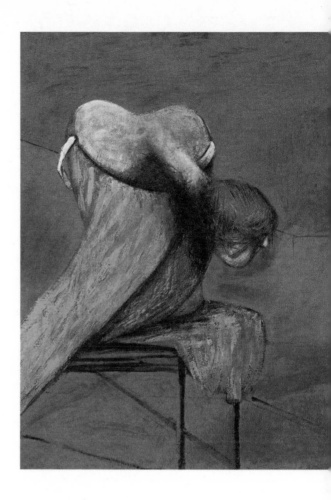

Myth and Tragedy

In the evolution of Francis Bacon's art, especially in its initial stages,
several motifs are repeated frequently. Some of them come from specific
paintings of the past, such as the portrait of Pope Innocent X by
Velázquez (pp. 10, 11), the Eisenheim Altarpiece by Matthias Grünewald, or
the Crucifixion by Cimabue (pp. 12-13). Others come from myths recounted
in literature, as with the themes taken from the Greek tragic poet
Aeschylus (pp. 86-87) or from T. S. Eliot (pp. 72-73). When Bacon uses such
materials, it is not a question of retelling their stories or giving a
literal recreation of earlier pictures, but rather of stripping those
original structures down to their essential human content. If Bacon used
themes from those sources to surround his work with an aura of tragedy,
he did so in order to suggest what evoked the primal scream shown in his
early canvases—the intimate violence of real things. These recurrent
motifs, therefore, function as meeting points between one's individual
life experience and a larger sense of myth—that ancestral repository
which has managed to preserve forms of representation appropriate to
complex, difficult subjects throughout the ages. The Crucifixions, the
bullfighting scenes, and the references to tragic literature selected by
Bacon, thus, have in common an urge to deal with conflicting feelings and
unknown forces—an urge, indeed, toward catharsis. Beyond the individual
interest of each work, these canvases provide the key to the type of
relationship Bacon sought to establish between viewers and his
paintings, something similar to the attitude we might assume before a
ritual whose meaning is unknown to us.

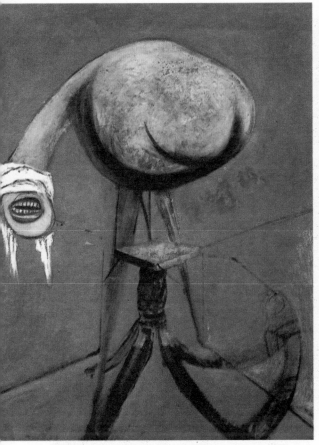
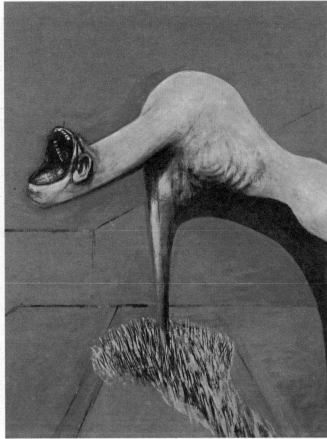

Three Studies for Figures at
the Base of a Crucifixion,
1944.
Oil and pastel on cardboard;
three panels, each 37 × 29 in.
(94 × 74 cm).
Tate Gallery, London.

The reference to the Crucifixion theme is only oblique—three
figures, the idea of mutilated bodies. The bulbous forms bear a
certain similarity to the monsters in some Surrealist canvases,
a movement with which Bacon's work had some early affinity. More
than four decades later, the artist painted a second version of
this composition (pp. 90-91).

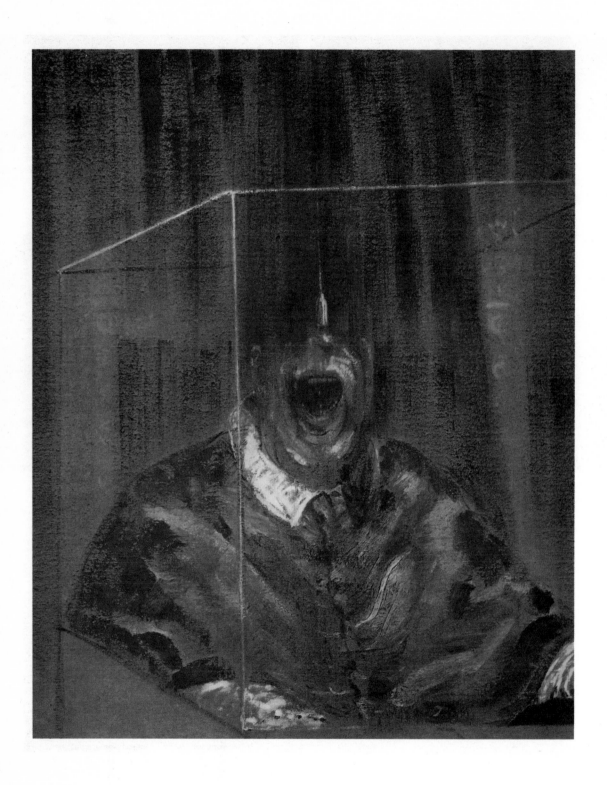

Head VI, 1949.
Oil on canvas,
36 ½ × 30 ¼ in. (93 × 77 cm).
Arts Council of Great Britain,
London.

The first trace in Bacon's work of the portrait of Pope Innocent X by Velázquez. The primal scream is the outstanding motif of these first canvases, where nearly the entire face disappears in shadow, leaving only the mouth that utters the cry.
The background is a sort of curtain of shadows from which the figure emerges.

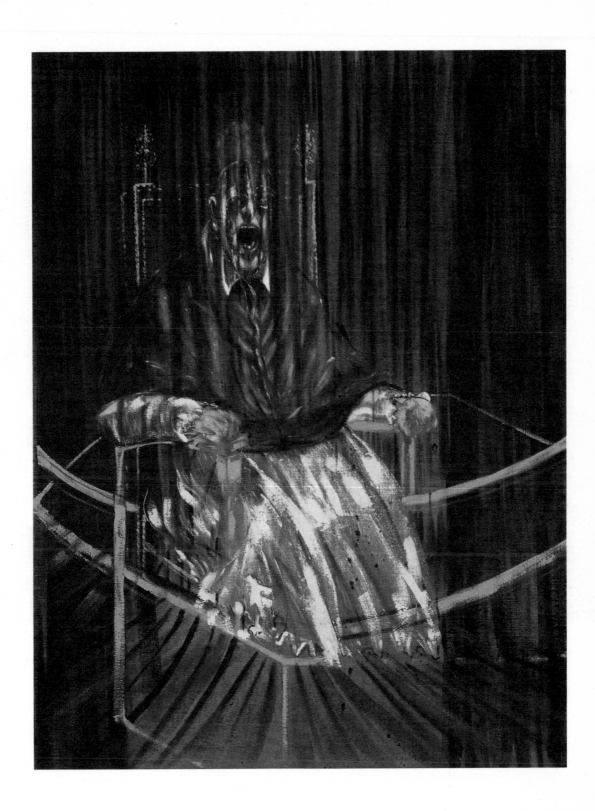

Study after Velázquez's Portrait of Pope Innocent X, 1953.
Oil on canvas, 60 × 46 ½ in. (153 × 118 cm).
Des Moines Art Center, Iowa. Coffin Fine Arts Trust Fund.

The veil placed between the viewer and the figure of the Pope crying out derives from the textures of X ray plates that Bacon often utilized in those years. The open mouth can be understood also as the result of a relaxing of the jaw that occurs in cadavers, which would well suit the spectral aspect of this figure.

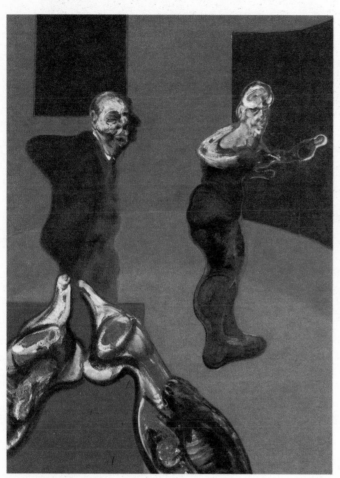

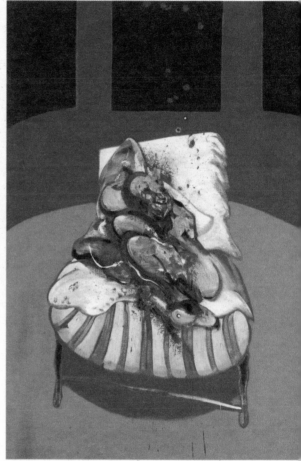

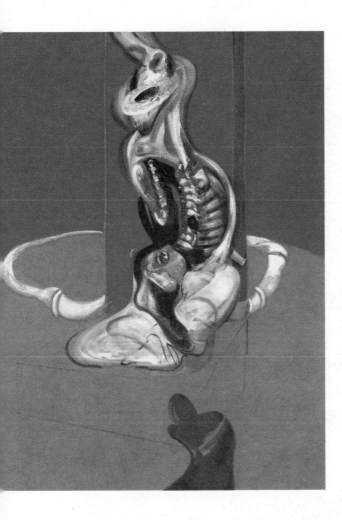

Three Studies for a Crucifixion,
1962.
Oil on canvas; three panels,
each 78 × 57 in. (198 × 145 cm).
Solomon R. Guggenheim Museum,
New York.

Almost twenty years after *Three Studies for Figures at the Base of a Crucifixion*, Bacon returned to its evocation of sacramental slaughter and to its triadic structure. The panel to the right represents an animal's carcass slit open, but its form was suggested by 13th century *Crucifixion* by Cimabue, when seen upside down.

*Studies for Portrait of
Van Gogh II*, 1957.
Oil on canvas, 78 × 56 in.
(198 × 142 cm).
Thomas Ammann Fine Art,
Zurich.

**Study for Portrait of
Van Gogh VI**, 1957.
Oil on canvas, 79.7 × 55.9 in.
(202.5 × 142 cm).
Arts Council of Great Britain,
London.

Throughout the year 1957, Bacon completed several variations
on the painting by Vincent van Gogh called *The Painter on
the Road to Tarascon* (1888); they are rare attempts in Bacon's
career to present an integrated treatment of figure and natural
surroundings. Unlike his reminiscences of Velázquez, Rembrandt,
or Muybridge, here the painter starts from something like the
pictorial and chromatic character of the original.

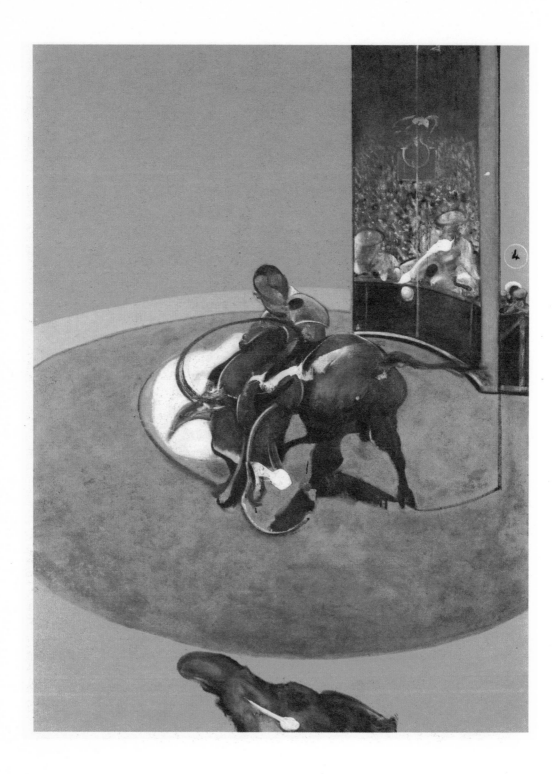

Study for Bullfight No. 1,
1969.
Oil on canvas, 78 × 58 in.
(198 × 147.5 cm).
Private collection.

Bacon was interested in bullfighting as a tragic ceremony, comparable in a way to Aeschylus's *Oresteia* or the Crucifixion. It is himself that the painter depicts in the ring, becoming a single form with the bull at the consummation of their encounter. Their union is highlighted by the curved black brushstroke, above the full spread of the cape, that connects the two. The painting's luminous flat hues give a certain emotional distance to the spectacle.

notable instances of a palpable shift in the zeitgeist were the poignant, phantasmal sculptures of Alberto Giacometti, the masterfully structured but erotically charged figure compositions of Balthus, and the powerful *art brut* images of Jean Dubuffet. As European artists assimilated the wartime experience, they conceived a new interest in the human image, reflecting an awareness, as never before, of man's condition of loneliness and his will to endure. Thus, they mediated the dominant Expressionist abstraction of an earlier period with a challenging new kind of tortured humanistic imagery.

Bacon dealt with an articulate existential dread and a profound sense of exasperation in the temper of the times by pushing his personal vision even further than the macabre clowning of Dubuffet and psychic distress of Giacometti. His preoccupation with terror was both instinctively theatrical and deeply disturbing in its psychological impact. Often it seemed siphoned directly from the most memorable and catastrophic media events, as he incorporated in his art grim reminders of the Holocaust and its death camps, whose visual evidence surfaced only after World War II. With his sense of Surrealist menace and images blurred as if in motion, Bacon stated the case for postwar European despair with a vehemence and an originality that earned him a special place among contemporary Cassandras.

Photographs from the late forties show Bacon's first Kensington studio cluttered with an accumulation of photographic reproductions that had caught his eye and that weighted his allusive art with a special quality of social gravity.[3] His sources were the daily newspapers, magazines, and such crime sheets as *News of the Week* in London and *Crapouillot* in Paris, all of which readily provided for his practiced eye a fertile image bank of the most notorious happenings and unsavory personalities of the period. The operative principle governing his reinvention of a compelling visual drama, drawing on this inventory of shameful events, was its mysterious topical concurrence with unseen psychological forces within himself. Violence, and its affront to personal stability or even sanity, was the common denominator of photographs showing war atrocities, Joseph Goebbels waggling a finger on a public platform, the bloody streets of Moscow during the October Revolution, the human carnage of a highway accident, fantastic scientific contraptions culled from the pages of *Popular Mechanics*, or a rhinoceros crashing through a jungle swamp.

The artistic issue of this raw photographic data proved unpredictable and without a direct precedent in past art despite Bacon's admitted affinities with the Surrealists. Once a new pictorial composite was creatively synthesized on the picture plane, its real life reference almost disappeared, but not entirely. Emotive antecedents continued to resonate in the paint as the unlaid ghosts of visual fact, no matter how distanced the final pictorial formulation might be. Somewhere between the simple cold mechanics of the camera and the most charged and tragic moments of recent European history, Bacon created a moving and crepuscular world of the imagination, reviving and transcending associations of violence and terror to arrive at his own unique kind of catharsis.

Bacon's introduction to an American public came shortly after the war, in 1948, when Alfred Barr acquired *Painting*, 1946 (p. 38), for the Museum of Modern Art. It is a faceless and brutal image of a dictator-like figure, part man, part ape, standing between two suspended carcasses of beef that suggest a slaughterhouse and perhaps, too, the influence of the shockingly cruel Surrealist film, *Un Chien Andalou*, 1928, by Salvador Dalí and Luis Buñuel. The monstrous humanoid creature at center stage in the painting is shielded by an emblematic umbrella, strangely reminiscent of Neville Chamberlain, the deluded British prime minister who tried futilely to conciliate Adolf Hitler on the eve of World War II. His visage dissolves into a lewd, simian

• • •

3 Hunter, "Francis Bacon," p. 12.

Figure and Space

The concept of representation takes on a double meaning in Bacon's
painting, for his works can be understood in almost theatrical
terms. From the 1950s onward a clear difference can be observed
between the treatment of the figure—violent, distorted, riven with
complexities—and the treatment of the space around it, which is
arranged like a bare stage. The contrast between the highly charged
figure and its relatively neutral, flat surroundings is part of the
visual theater designed by the artist; he places the painting's
viewer in the same situation as a spectator at a peep show—
confronting a figure displayed at a moment of profound intimacy,
held in a linear box like a cage. It is made clear that the space
enclosing the figure encompasses the viewer as well, since the box
is simply an extension of the viewer's lines of perspective.

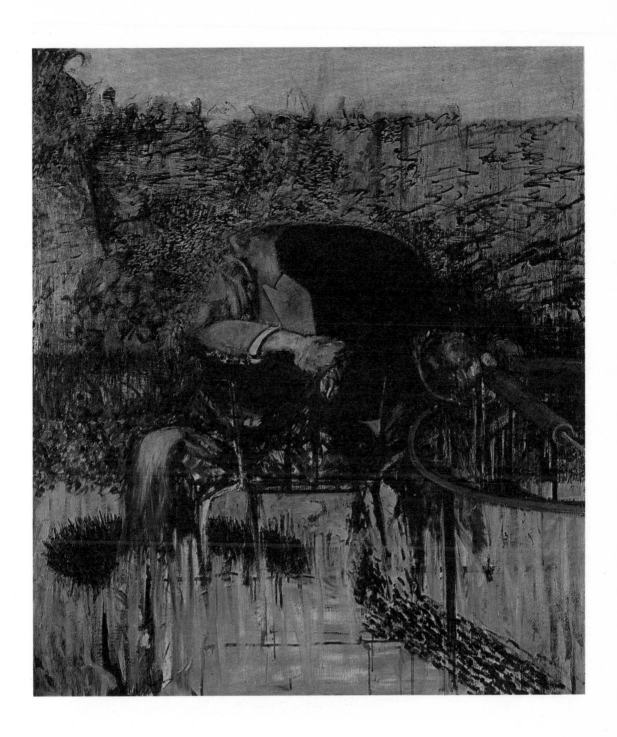

Figure in a Landscape, 1945.
Oil and pastel on canvas,
57 × 50 in. (145 × 128 cm).
Tate Gallery, London.

The image of the person
seated on the park bench is
fused with the surroundings,
emerging from them in an
unexpected fashion. Bacon
had not yet developed the
kind of pictorial space that
appears in the 1950s.

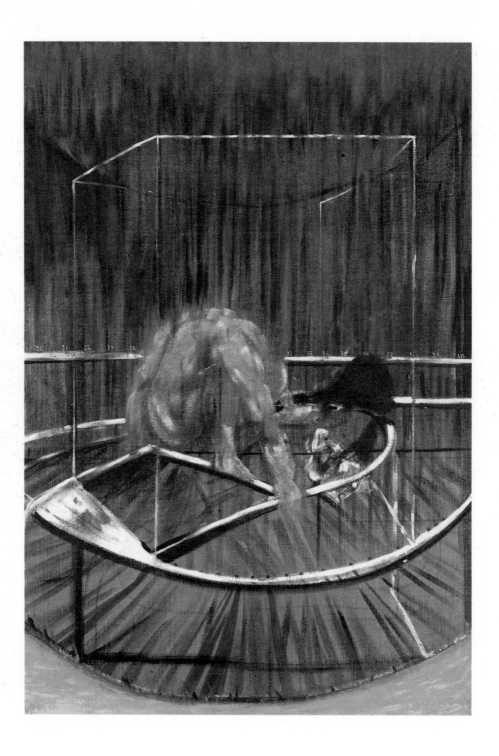

Study for a Crouching Nude,
1952.
Oil on canvas,
66 × 54 in. (198 × 137 cm).
The Detroit Institute of Arts.
Gift of Mr. William R.
Valentiner.

The tension in this figure derives directly from Michelangelo's nudes. Yet the figure is given an elusive, almost vaporous pictorial treatment that contrasts with the definite linear prism in which it is contained. It contrasts as well with the circular space, like a circus ring, whose rigid physicality is emphasized by the numerical calibrations marked on the railing behind the figure.

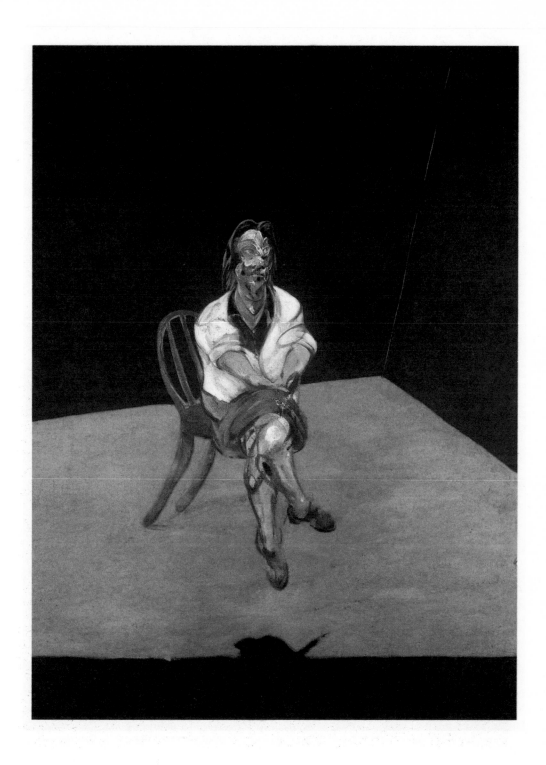

*Study for a Portrait
(Isabel Rawsthorne)*, 1964.
Oil on canvas,
78 × 58 in. (198 × 147.5 cm).
Private collection.

The lack of spatial coordination between the subject and the
chair on which she sits—a constant in many of the painter's
portraits—reveals to what extent they obey different pictorial
systems. The picture's effect arises from this contradiction.

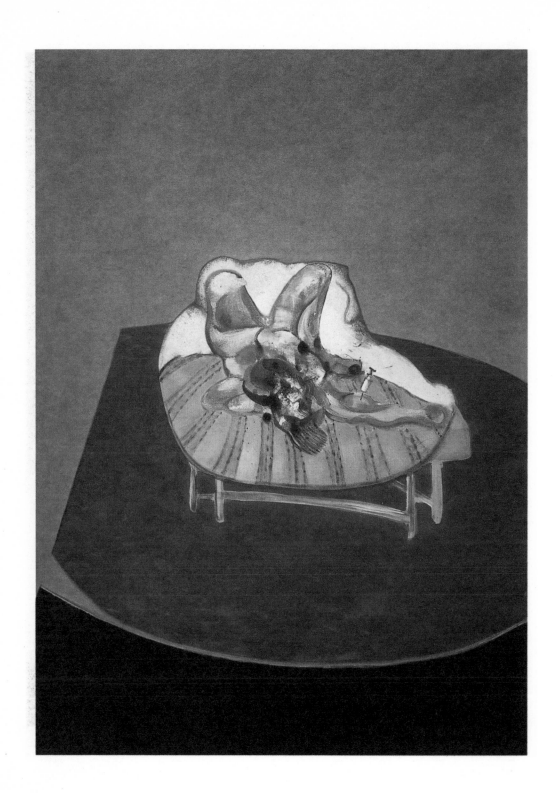

*Lying Figure with Hypodermic
Syringe*, 1963.
Oil on canvas,
78 × 57 in. (198 × 145 cm).
Private collection,
Switzerland.

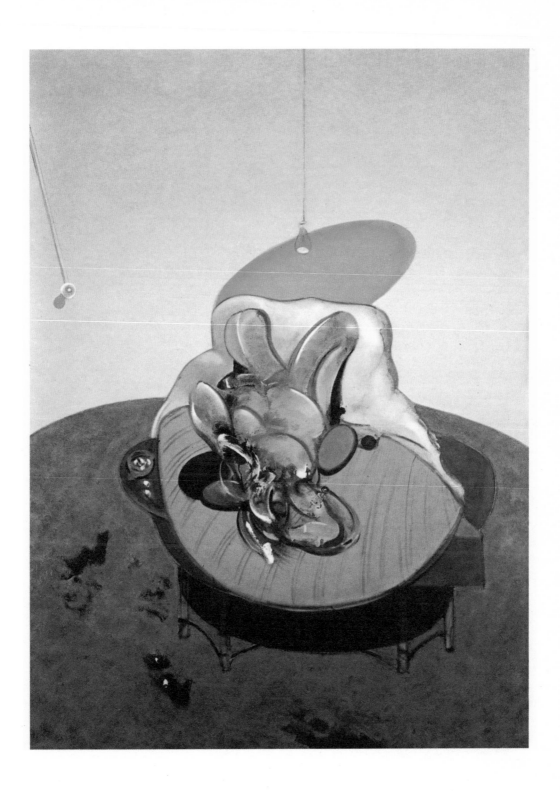

Lying Figure, 1969.
Oil on canvas,
78 × 58 in. (198 × 147.5 cm).
Riehen/Basel, Fondation
Beyeler, Switzerland.

The same subject is repeated
with six years' difference. In
the second version the motif
of the needle disappears, and
instead the light bulb and
switch appear, activating the
space above the figure.

grimace and gaping wound while the platform fuses into some sort of barred contraption, suggesting both a cage and medieval rack, that seems to have a machine gun mounted on it. A conventional heroic representation of a public figure disintegrates before our eyes, first in an unwholesome, poisonous, "real" atmosphere and then internally in psychological space.

Bacon disdains the kind of methodical literary or conceptual interpretation that places reductive limits on his meaning. When the art critic Sir John Rothenstein speculated that the imagery of *Painting* (p. 38) could be read as a dualism of spirit and carnality, Bacon was quick to turn aside the suggestion. Surprisingly, he focused on the painting's far fetched and unrelated beginnings, noting that he originally had in mind the representation of a bird of prey alighting on a plowed field. The carcasses were inspired by his childhood fascination with butcher shops. The distance he traveled from his original intention, Rothenstein noted, was the result of a deliberately controlled reverie and process of automatism, which invited free association and an unusual psychological entry into subject matter. He became, in Rothenstein's apt formulation, "a sort of figurative action painter working under the spell of the subconscious."[4]

Conditioned by both the horrors of World War II and vivid memories of a violent and troubled childhood in revolution torn Ireland, Bacon presents a complex web of intriguing contradictions as a man and artist. A late starter, he claims he had "no upbringing at all… I used simply to work at my father's racing stable near Dublin."[5] His father bred and trained horses, and the family frequently moved, making Bacon's schooling erratic. He has said, "I read almost nothing as a child—as for pictures, I was hardly aware that they existed."[6] He left home at an early age to try his luck in London and then traveled on the Continent, testing the sensual freedom of Berlin but finally preferring the artistic liberation of Paris. Without formal art training, he began painting on his own in the 1920s after seeing a Picasso exhibition but did not attract much notice or support. Then he turned to a related discipline in the applied arts, working in a mixture of Constructivist and Art Deco styles and briefly eliciting interest as a furniture designer and interior decorator. His tubular Bauhaus furniture has persisted in his painting, in a transformed state, as the geometric space frames in the background. They are part of a complex system of formal mechanics, bridging abstraction and representation, that distill and fix his powerful imagery permanently in memory.

Although he resumed painting in a desultory fashion in the late thirties and early forties, Bacon achieved public recognition only in the late forties and early fifties with his obsessive grimacing and screaming popes (pp. 10, 11) and related work of a similar visionary force. One does not soon forget these sensational images of hysteria and nightmare in paint, which spoke so eloquently to our postwar distress. The celebrated series shockingly paraphrased and reversed Velázquez's sumptuous and magisterial seventeenth century portrait of Pope Innocent X in the Doria Palace in Rome. Bacon's vivid invention transformed the crafty and smug prince of the church into a threatening, even depraved, modern image. Influenced by early film classics as well as tabloid journalism, in his "Pope" series Bacon incorporated photographic images of gunmen, Eadweard Muybridge's motion studies of the late 1880s, and the dying nurse—mouth agape and pince nez shattered—from Sergei Eisenstein's film *Battleship Potemkin*, 1925. There were also the fragmentary intimations of classic news photographs of Hitler and his barbarian lieutenants, all conspiring to create a half real, half fantastic world of powerful psychological immediacy, a public chamber of horrors and private nightmare.

• • •

4 John Rothenstein, *Francis Bacon*, exhibition catalogue (London: Tate Gallery, 1962), unpaginated.
5 Davies and Yard, *Francis Bacon*, p. 11.
6 Ibid.

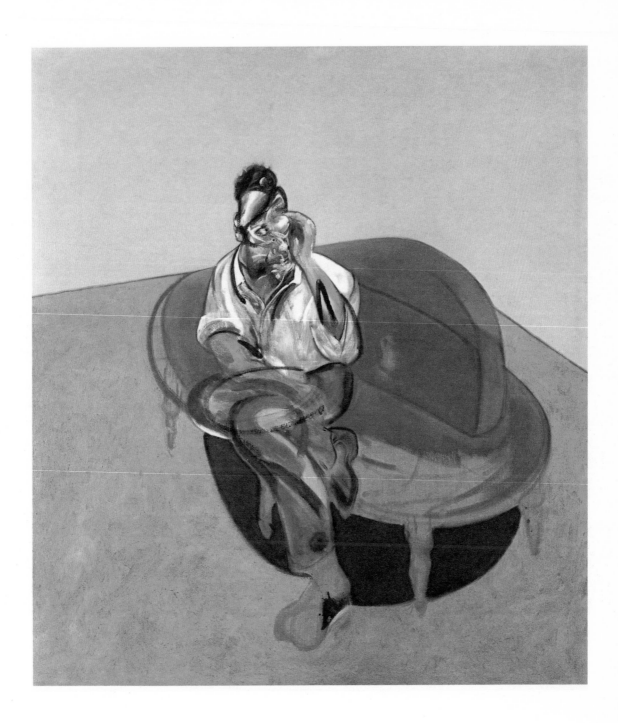

*Portrait of Lucian Freud
(on orange couch)*, 1965.
Oil on canvas,
61 ½ × 54 ¾ in.
(156 × 139 cm).
Private collection,
Switzerland.

The human figure focuses on
the energy of the canvas,
absorbing everything around
it. The massive rotundity of
the sofa seems to deflate
behind the figure, at the
point of contact between
figure and setting.

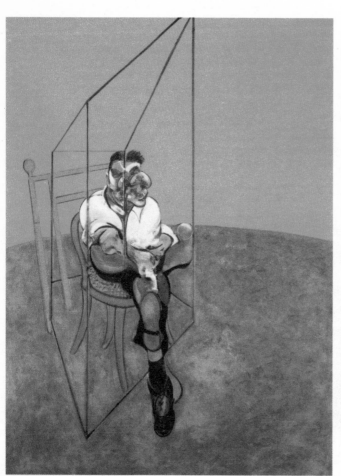
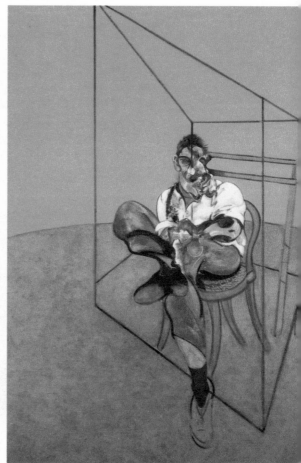

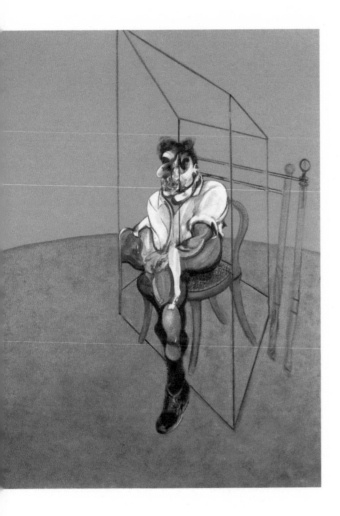

Three Studies of Lucian Freud, 1969.
Oil on canvas; three panels,
each 78 × 58 in.
(198 × 147.5 cm).
Private collection.

The triptych multiplies the visual possibilities in the interplay between figure and surroundings. The turning of the spatial prism encasing the figure in each panel generates a sequence of facial distortions. In the left panel, the different facets of the prism produce the faceted presentation of the face, shown in both frontal and profile view simultaneously, as Picasso had done.

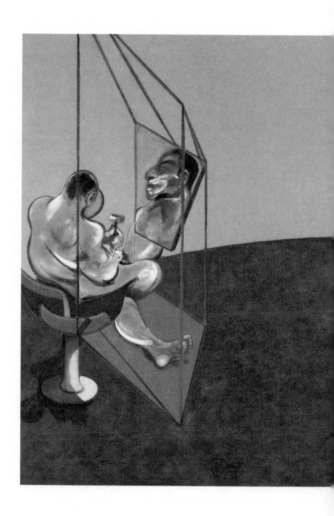

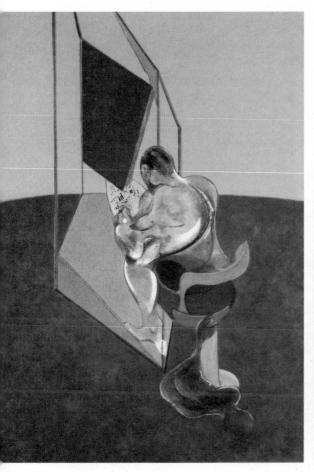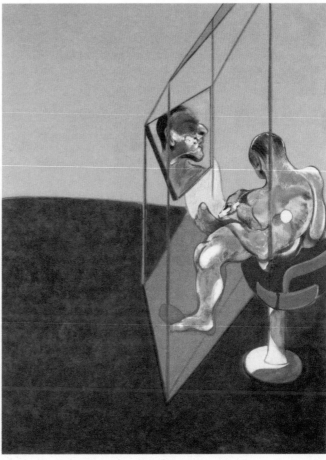

*Three Studies of the Male
Back*, 1970.
Oil on canvas; three panels,
each 78 × 58 in.
(198 × 147.5 cm).
Kunsthaus, Zurich.

The different positions of the
mirror offer a paradoxical
sequence, whose aim is to
disturb and question the
relationship of the viewer
to the painting. The high,
diagonal point of view, as in
an architect's axonometric
drawing, accentuates the idea
of the individual surprised
in his privacy.

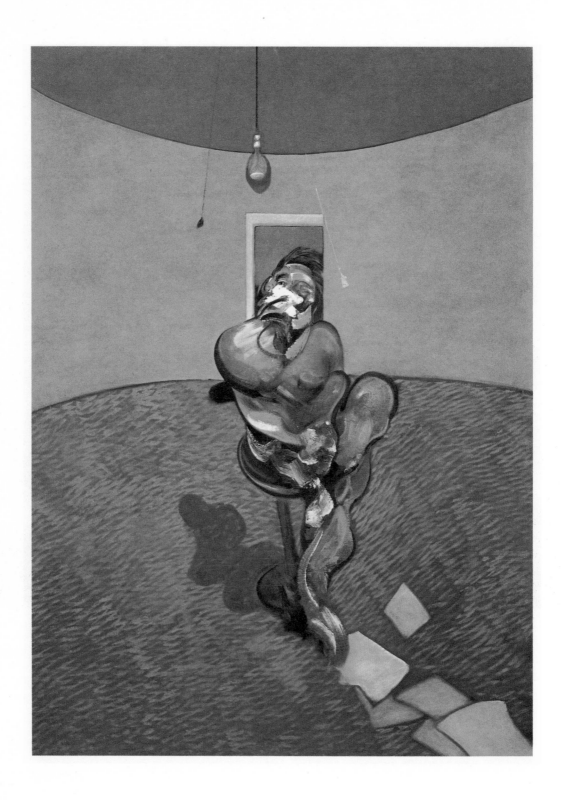

***Portrait of George Dyer
Talking***, 1966.
Oil on canvas, 78 × 58 in.
(198 × 147.5 cm).
Private collection.

The light bulb and swinging tassel hanging from the ceiling
accentuate the spiral space enveloping the figure. Bacon takes
this idea from several Italian Renaissance painters, such as
Piero della Francesca, who depicted an egg hanging on a string
from the cupola that protects the figure in his famous Madonna
in the Pinacoteca Brera in Milan.

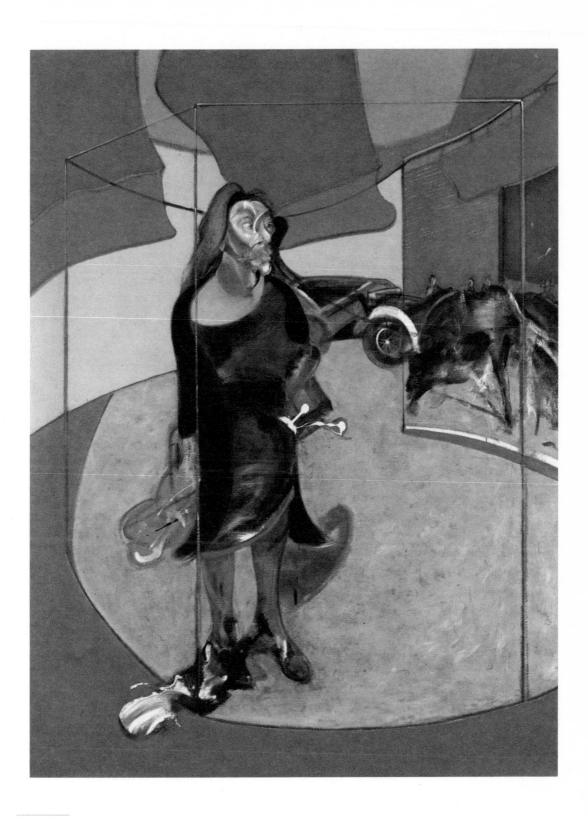

**Portrait of Isabel Rawsthorne
Standing in a Street in Soho,**
1967.
Oil on canvas, 78 × 57 ¾ in.
(198 × 147 cm).
Staatliche Museen
Preussischer Kulturbesitz,
Nationalgalerie, Berlin.

Bacon rarely places his figures in an exterior setting. When he
does, the theatrical artifice of his painting becomes more
evident. In this painting, the street is suggested by means of a
kind of backdrop behind the linear box. However, the scene does
not lose its immediacy from this, and perhaps because of that
tour de force the canvas always remained one of Bacon's
favorites.

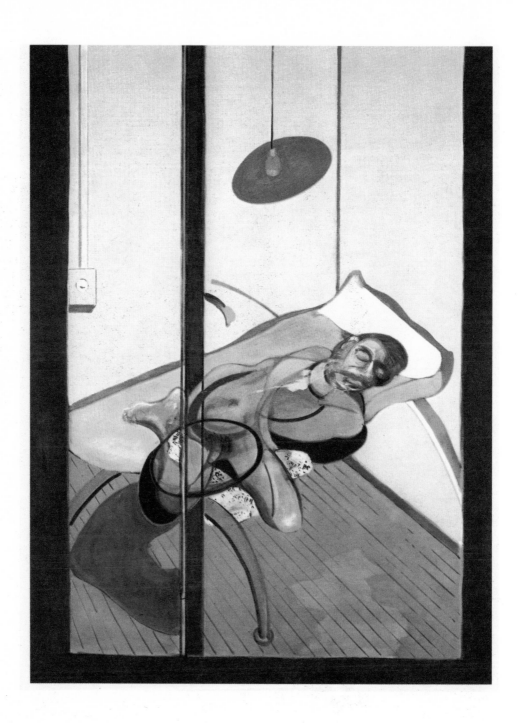

Sleeping Figure, 1974.
Oil on canvas, 78 × 58 in.
(198 × 147.5 cm).
Collection A. Carter Pottash.

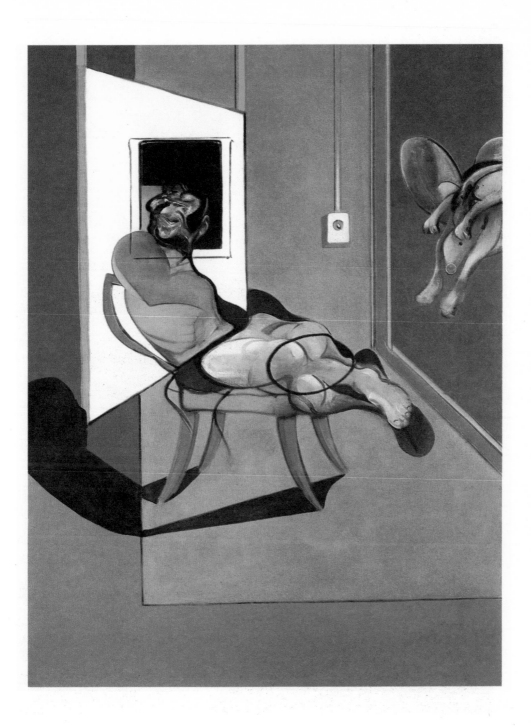

Seated Figure, 1974.
Oil on canvas, 78 × 58 in.
(198 × 147.5 cm).
Private collection.

Two examples of how the painter exploits the relationship
between figure and space. In these two canvases the figure
appears trapped in his pose, crushed against the chair or the
bed as though he were only a vestige of himself, his mere
lifeless skin, molded by the pressing weight of the surrounding
space upon him.

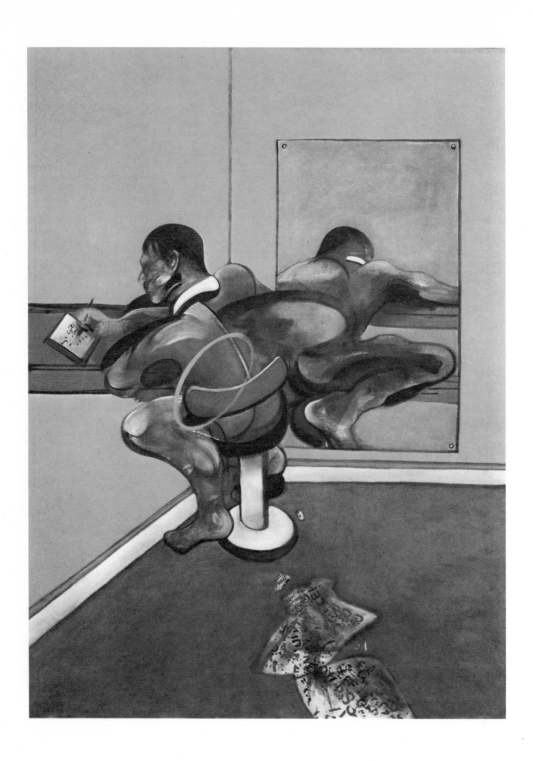

Figure Writing Reflected in a Mirror, 1976.
Oil and pastel on canvas,
each panel, 78 × 58 in.
(198 × 147.5 cm).
Private collection.

The figure and its reflection
are fused, like Siamese twins.
The mirror offers an image of
the back of the figure that is
physically impossible, given
the angle of the mirror's
placement as seen in the
canvas. The illegible text of
the newspaper on the floor
reinforces the paradoxical
effect of the work.

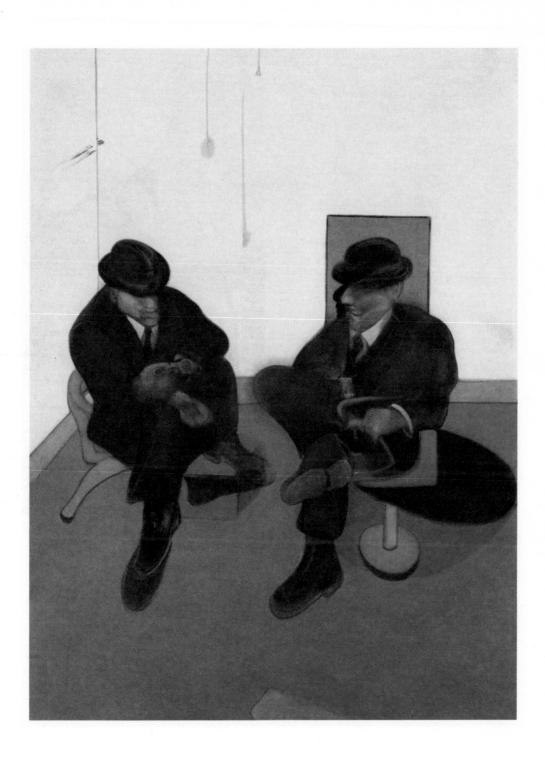

Two Seated Figures, 1979.
Oil and pastel on canvas,
each panel, 78 × 58 in.
(198 × 147.5 cm).
Galerie Beyeler, Basel.

The two figures, with the look
of business men in the
waiting room of a station,
occupy a closed, domestic
space. The surprising
verisimilitude of the chairs
derives from Bacon's early
experience as an interior
designer.

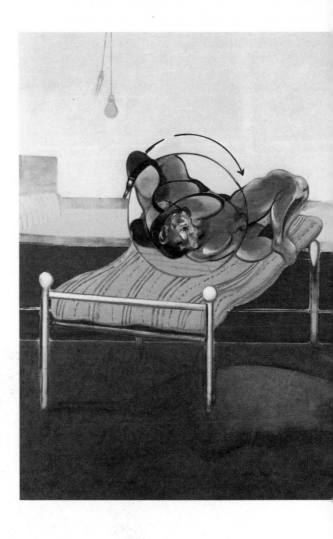

Violated Flesh

Bacon understood his figures as coming into being through a kind of
creative violence; they were made manifest through his vigorous
physical manipulation of the paint with his own hands. That material
violence remains imprinted in what is depicted, in such a way that
Bacon's figures appear as a turbulent mass of lacerated, wounded,
tense flesh. In this respect even his paintings of the butchered
carcasses of animals should not surprise the viewer; not only are
they a natural outgrowth of his concern with the flesh and blood
actuality of the body, but such depictions have a long history in art,
as in some of the canvases of Rembrandt and other Dutch painters
of the 17th century.

Equally important in Bacon's treatment of the body was the use of
some photographs by Eadweard Muybridge that analyzed movement
through sequential images of wrestlers. Bacon transformed those
detached, frozen scenes into violently carnal confrontations,
exploiting all their potential for aggressive, orgiastic combat.

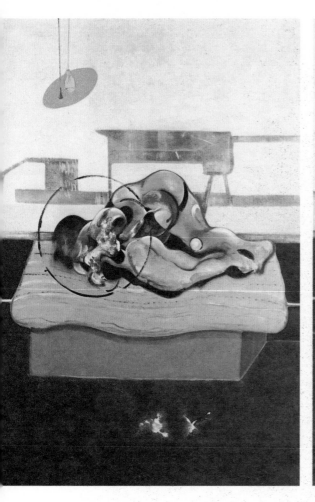
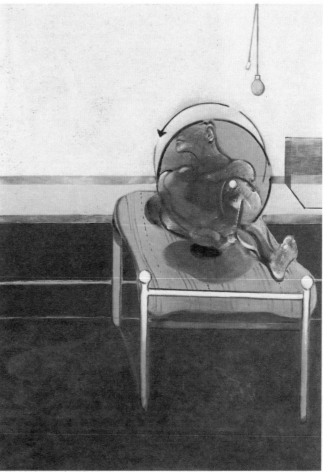

Three Studies of Figures on Beds, 1972.
Oil and tempera on canvas; three panels, each 78 × 58 in. (198 × 147.5 cm).
Private collection.

The figures struggling on the bed derive from Eadweard Muybridge's photographs of wrestlers. Their contorted positions constitute the canvas's whole substance, to the point where it is almost impossible to distinguish one body from another: we see a single mass of flesh whose muscular torsion is reinforced, with the coldness of a diagram, by the circles and arrows superimposed by the painter.

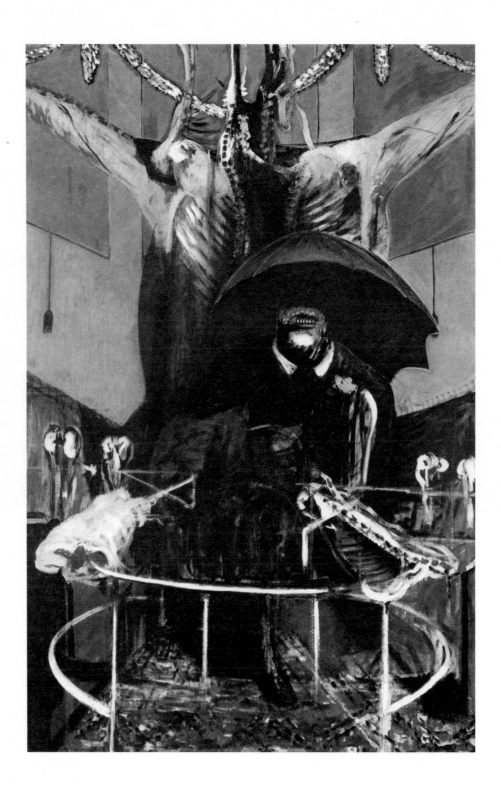

Painting, 1946.
Oil and tempera on canvas,
78 × 52 in. (198 × 132 cm).
The Museum of Modern Art,
New York.

This macabre picture, in which a terrifying figure with clerical garb sits in the midst of a scene of slaughter, was one of the works that brought international recognition to Bacon, when it was acquired by the Museum of Modern Art, New York, in 1948. The umbrella motif, repeated in other works of this period, is the forerunner of the linear prisms that later delimit the space around the figure. Twenty five years later, Bacon returned to the same theme, although the figure now wears a business suit and a raincoat, and the artist's palette is brighter.

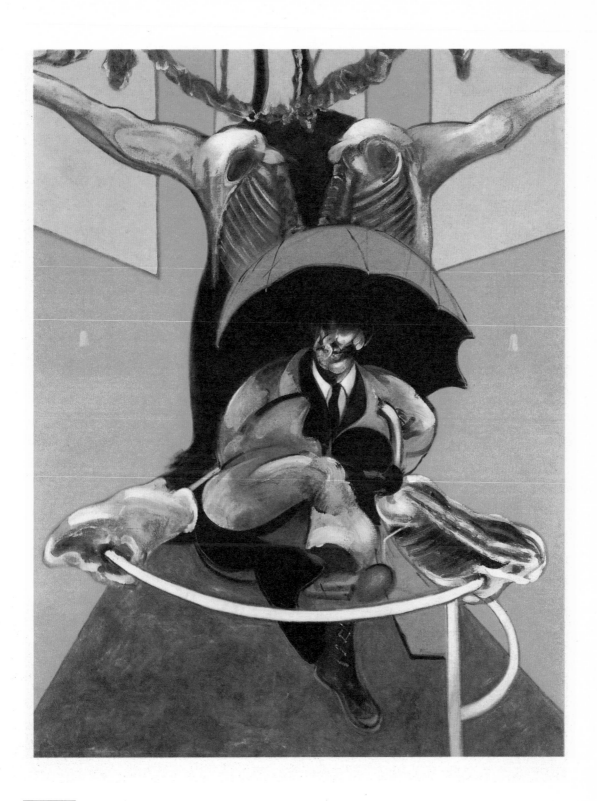

Second Version of Painting
1946, 1971.
Oil on canvas,
78 × 52 in. (198 × 147,5 cm).
Ludwig Museum, Colonia.

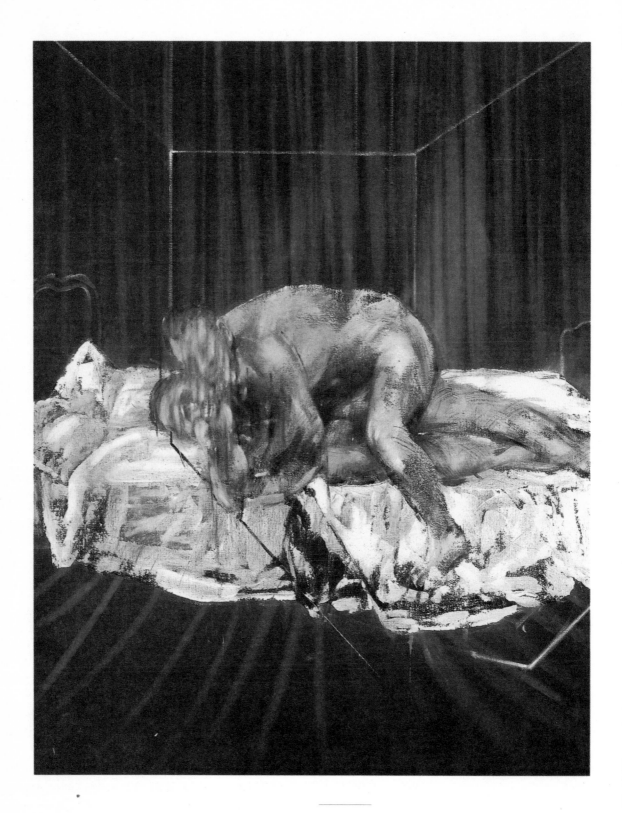

Two Figures, 1953.
Oil on canvas,
60 × 46 in. (153 × 116 cm).
Private collection.

One of the first appearances
of Muybridge's wrestlers.
By changing the figures'
setting, Bacon has changed
the athletic struggle of the
original photograph into a
passionate, even violent
sexual encounter.

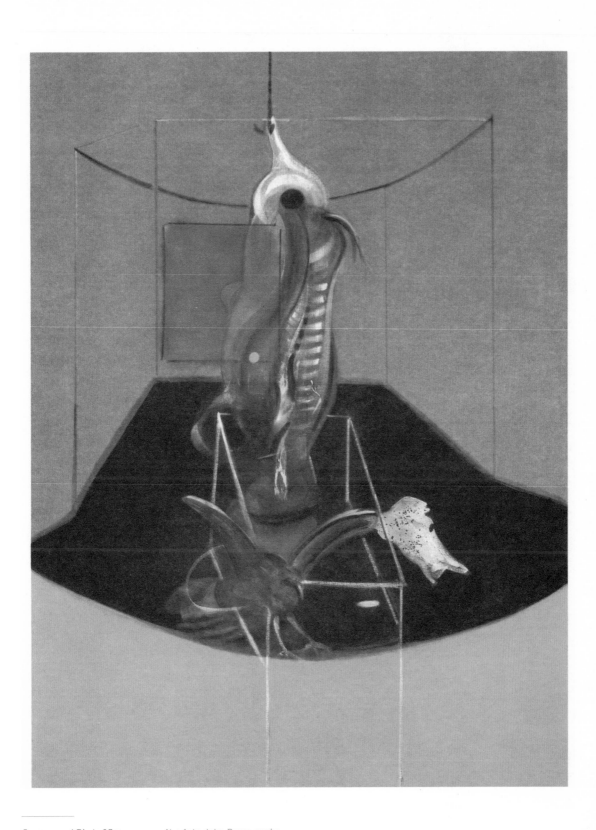

Carcass and Bird of Prey,
1980.
Oil and pastel on canvas,
78 × 58 in. (198 × 147.5 cm).
Private collection.

At a late date, Bacon again
presents us with an image of
butchered meat. And in a
depiction based on the
earlier use of X ray pictures,
the bird of prey is shown with
a fleshless skull.

Figure and Movement

"Michelangelo and Muybridge are mixed up in my mind together, and
so I perhaps could learn about positions from Muybridge and learn
about the ampleness, the grandeur of form from Michelangelo.... As
most of my figures are taken from the male nude, I am sure that I have
been influenced by the fact that Michelangelo made the most
voluptuous male nudes in the plastic arts." Bacon here describes
two of the sources from which his work derives. It is not so much the
representation of movement itself in Muybridge that interests him as
a certain sense of ritualized action that the poses convey.
Similarly, it is not simply the imposing muscular tension of
Michelangelo's nude figures—their famous *terribilità*— that affects
him. In contrast, the tension within Bacon's figures, so often in
awkward or unlikely positions, is nervous and tentative. What he
seeks to create on the canvas is a sense of the figure as the center
of swirling energies—in its movement or in its own inner tension.
And he conveys those energies through the traces of the moving hand
that wields the paintbrush.

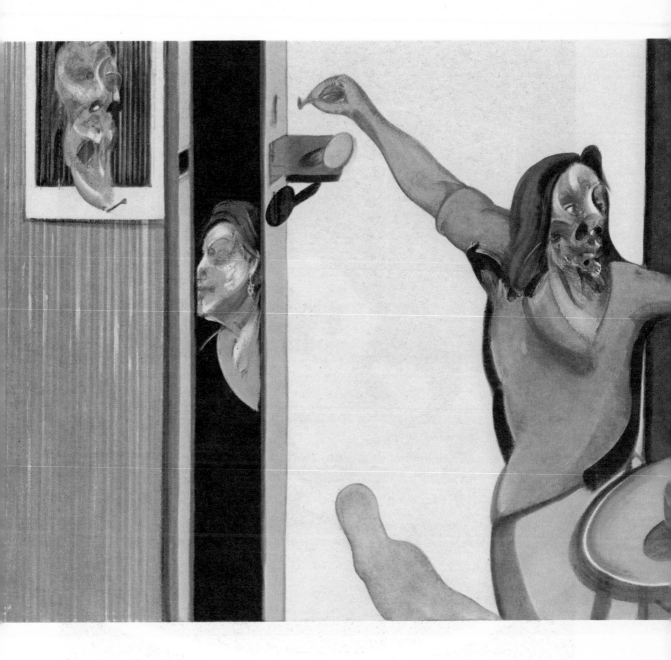

Three Studies of Isabel Rawsthorne, 1967.
Oil on canvas,
46 ¾ X 60 ½ in.
(119 × 153.7 cm).
Staatliche Museen
Preussischer Kulturbesitz,
Nationalgalerie, Berlin.

The sequence of images seen
in the triptychs is here
condensed into a single
panel, with a separate
rectangular area for each
face. One of the three studies
is presented as a picture
pinned to the wall.

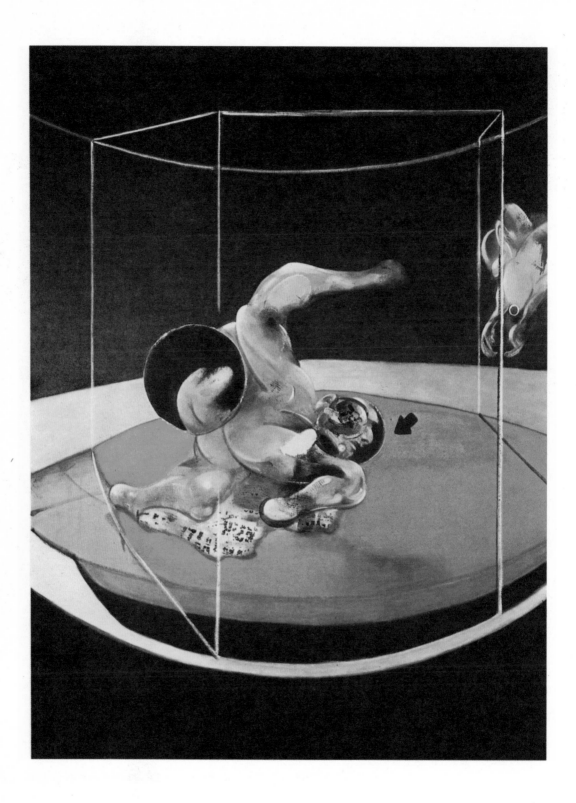

Figure in Movement, 1976.
Oil on canvas, 78 × 58 in.
(198 × 147.5 cm).
Private collection.

The circles, functioning like magnifying glasses on the foci
of tension, and the arrows that complete the basic directions of
movement in an analytical fashion, are two sources of dynamism
in Bacon's canvases. The fusion of two successive positions in
a single figure, like a stroboscopic photograph, has been a
feature employed by painters since the time of the Futurists,
but it takes on a distinctive sense in Bacon.

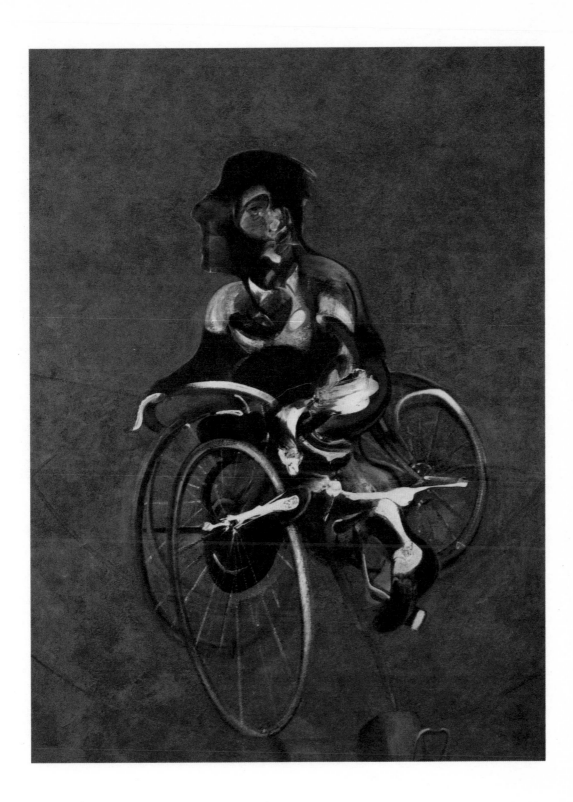

Portrait of George Dyer
Riding a Bicycle, 1966.
Oil on canvas,
78 × 58 in. (198 × 147.5 cm).
Beyeler Collection, Basel.

The figure exhibits many of its dynamic possibilities: the direction of the bicycle, the positions of the leg pedaling, and the face viewed both frontally and in profile. The resultant whirlwind frozen in motion lends intensity to a seemingly innocuous image.

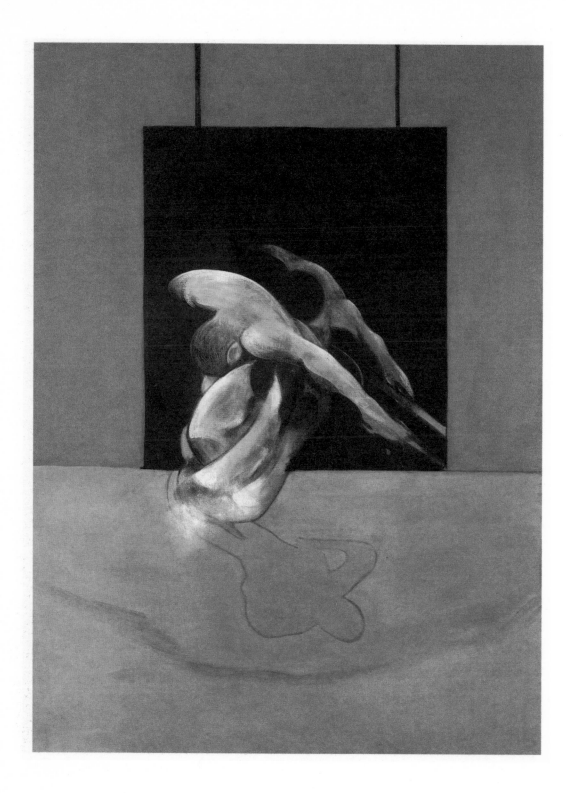

Figure in Movement, 1976.
Oil on canvas, 78 × 58 in.
(198 × 147.5 cm).
Private collection.

The movement itself here seems to mold the forms of the body,
another source of dynamic tension in Bacon's artistic language.

These and other idiosyncratic images of the forties and fifties bear witness to the trauma of World War II and the cold war aftermath, but they also signify more broadly man's innate capacity for violence. They can also be understood as the modern Freudian equivalent of Goya's savage visual commentaries of man's infinite capacity for irrational cruelty in *The Disasters of War*, 1810-14. For Bacon, however, pain and suffering are neither exceptional and intermittent nor limited to the ravages of war. Pain is continuous and irremediable, inseparable from individual consciousness. The only joy for the artist, he once observed, comes in the manipulation of paint, through the act of painting. Bacon's first sympathetic English critic, Robert Melville, complimented the artist on his power and freedom of execution but noted that Bacon's bravura pictorial effects occurred in the atmosphere of a concentration camp. His howling prelates and intertwined sadomasochistic couples, set within veiled dream spaces and defined by transparent perspective boxes or a proscenium space, seemed to have anticipated the obscene image of Adolf Eichmann, who was protected from the rage of his victims by a bulletproof glass box during his trial for war crimes.

Bacon continued to paint individual figures after his "Pope" series in *Study for a Portrait*, 1953 (p. 51), and the "Man in Blue" series, 1954. The ceremonial setting and appurtenances have been modified to accommodate a more anonymous, modern day theme of life in hotel bedrooms. These are rare instances of work painted directly from real life models, rather than from photographs or memory. They contain the ambiguity found in so much of Bacon's painting by presenting the human figure as both victim and ruthless interrogator. It was a period when Senator Joseph McCarthy was running amock in America, humiliating his victims in Congressional hearings and the press. Bacon reverses the conventions of modern realism in his figure studies, however. Instead of pretending his stage is a specific and identifiable public or private place, he takes a familiar space (art critic John Russell aptly dubbed it the "universal room") and converts it into a metaphysical platform by giving actual individuals and the sensational events of their lives new form and meaning. In doing so, Bacon brings to the surface fresh levels of awareness, both mythic and psychological, that range far beyond the scope or intention of any contemporary realism. At the same time, he recalls an oppressive and claustrophobic postwar period by creating an image of hell in the form of anonymous and sordid hotel bedrooms that are reminiscent of the paralyzing, affectless settings of Jean Paul Sartre's *No Exit*, 1942, and Samuel Beckett's *Endgame*, 1957.

Paradoxically, even at his most gruesome and disquieting, Bacon also manages to inject a sense of exuberance and catharsis into his work. In his introduction to the catalog for Bacon's retrospective exhibition in Moscow, Grey Gowrie captured exactly, it seemed, the artist's "gaiety" and grace under pressure, noting that he conveyed "the same feeling of a civilization undergoing nervous breakdown that we find in Eliot's poem *The Waste Land* ('These fragments I have shored against my ruin') although the prevailing mood is of relish rather than disgust."[7] Bacon has admitted, however, that one of his goals is to meet the challenge of a violent age by reviving in a meaningful modern form the primal human cry and to restore to the community a sense of purgation and emotional release associated with the tragic ritual drama of Aeschylus and Shakespeare.[8] Bacon has the faculty of a particular genre of visionary artistic genius, also evident in Bosch, Goya, Picasso, and other masters of the macabre, of clothing his most shattering and repugnant images, taken directly from the id as it often seems, in shimmering veils of seductive colored pigment. Despite the demonism of his imagery, his brushwork is closer to the French Impressionists than Northern European Expressionists.

· · ·

7 Grey Gowrie, in *Frensis Bekon: zhivopis'*, exhibition catalog (London: British Council and Marlborough Fine Art, 1988), p. 20.

8 Francis Bacon, interview by the author, June 22, 1988.

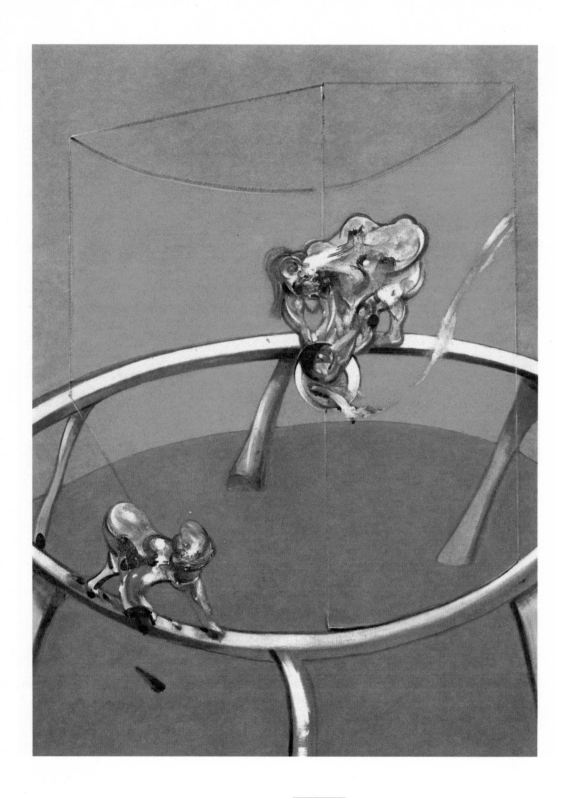

*From Muybridge—Studies of
the Human Body—Woman
Emptying a Bowl of Water and
Paralytic Child on All Fours,*
1965.
Oil on canvas, 78 × 58 in.
(198 × 147.5 cm).
Stedelijk Museum, Amsterdam.

Another transposition of
Muybridge's photographs from
which Bacon took physical
movement to create pictorial
tension.

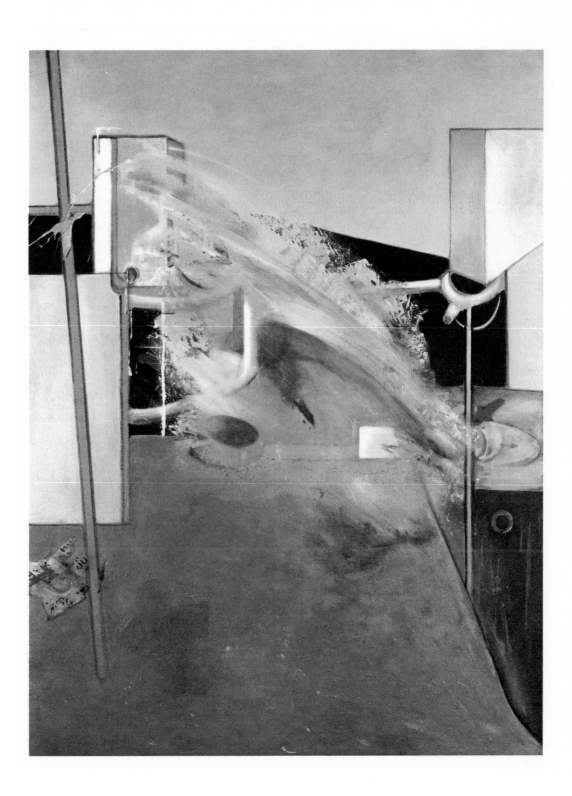

Jet of Water, 1979.
Oil on canvas, 78 × 58 in.
(198 × 147.5 cm).
Private collection.

Bacon made pictures of water currents and sand dunes whipped by
the wind, seeking to reproduce their dynamic behavior materially,
through the very application of paint. They constitute another
attempt to recreate experience with immediacy.

Portraits of Friends

The human presence is basic to all of Bacon's work. Thus it is not
strange that portraiture comprises the most abundant genre in his
production. Yet there is something unexpected about his painting
portraits: in the pictorial tradition, the portrait has often been
seen as a second class form, and its principal function, moreover,
was illustrational. A portrait painter is generally expected to
illustrate the social or professional condition of the subject. Bacon
transformed what a portrait could be. In the 1960s his closest
friends became his models. In another unusual step, Bacon
customarily employed mundane snapshots as a reference rather than
have his models present. Painting from photographs helped Bacon
maintain a certain objective distance. Yet paradoxically, his freedom
from the subjects' actual presence allowed him to recreate them with
remarkable immediacy. He said, "In trying to do a portrait, my ideal
would really be just to pick up a handful of paint and throw it at the
canvas and hope that the portrait was there."

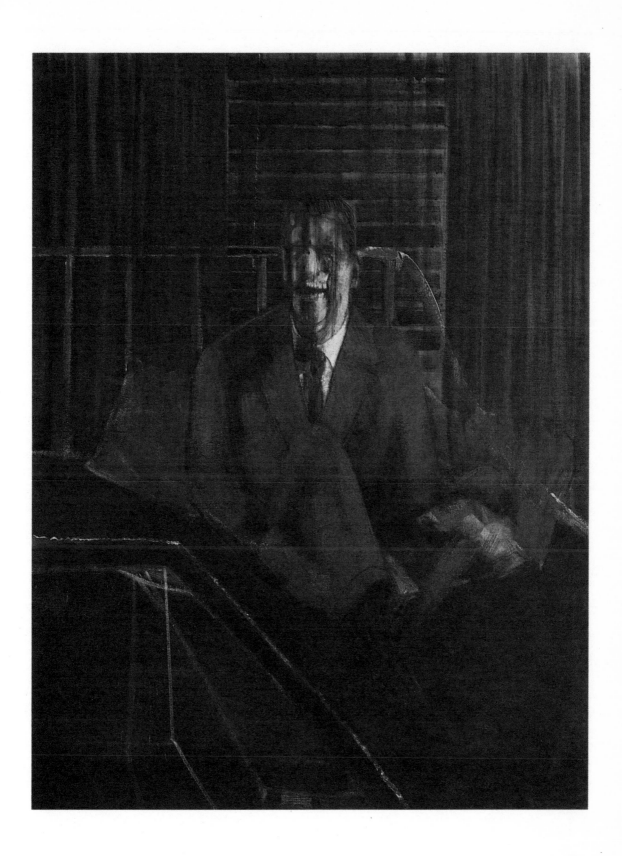

Study for a Portrait, 1953.
Oil on canvas,
60 × 46 ½ in. (152 × 118 cm).
Kunsthalle, Hamburg.

The portraits made before the 1960s are somewhat generic,
lacking particularized identities. They can be understood as
the artist's reflections on the possibilities of the form,
similar to the images based on Velázquez in the same period.

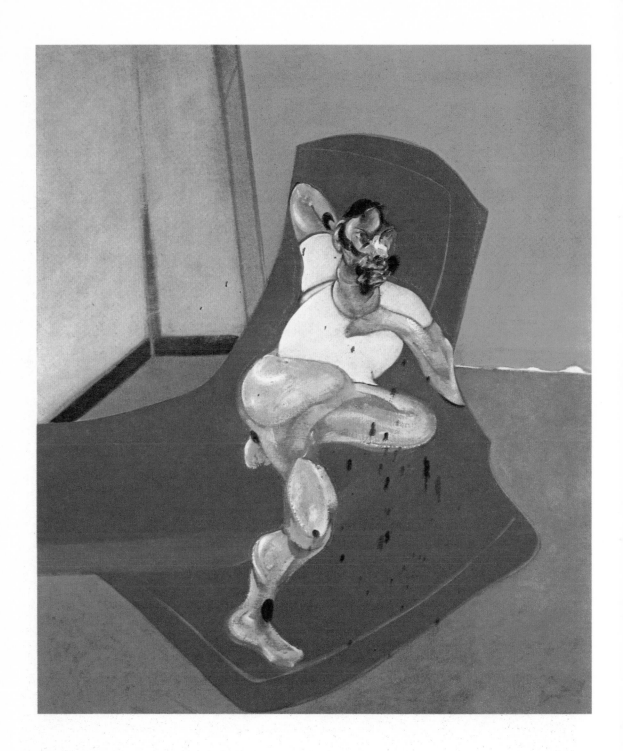

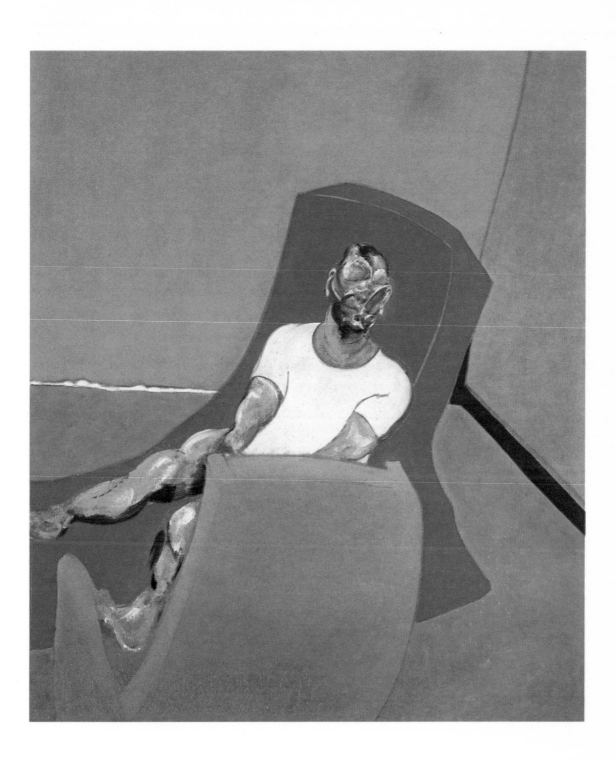

Double Portrait of Lucian
Freud and Frank Auerbach,
1964.
Oil on canvas, two panels,
each 65 × 57 in.
(165 × 145 cm).
Moderna Museet, Stockholm.

Bacon's friendships with the two figurative artists Frank
Auerbach and, in particular, Lucian Freud were not accidents.
Even though their work was quite different from Bacon's, they
were among the few contemporary artists whose pictorial
universe one can relate to Bacon's.

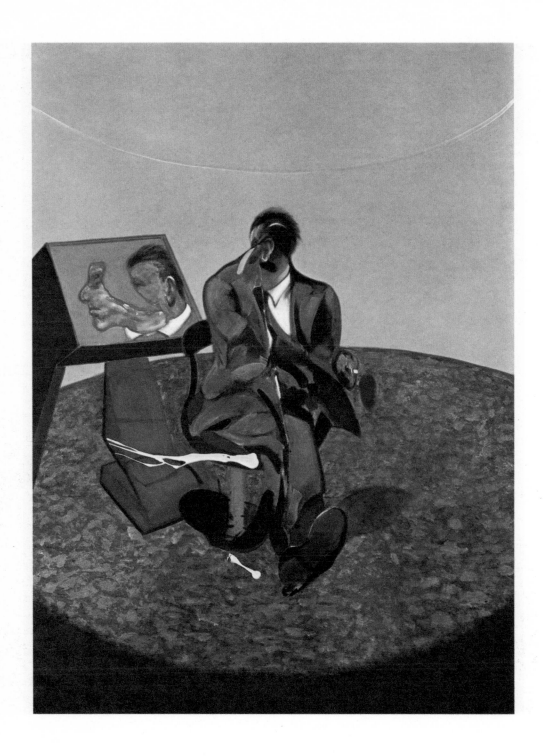

***Portrait of George Dyer in a
Mirror,*** 1968.
Oil on canvas,
78 × 58 in. (198 X 147.5 cm).
Thyssen-Bornemisza
Foundation, Madrid.

From the early 1960s until
his death in 1971, George
Dyer would be the portrait
subject most frequently
painted by Bacon.

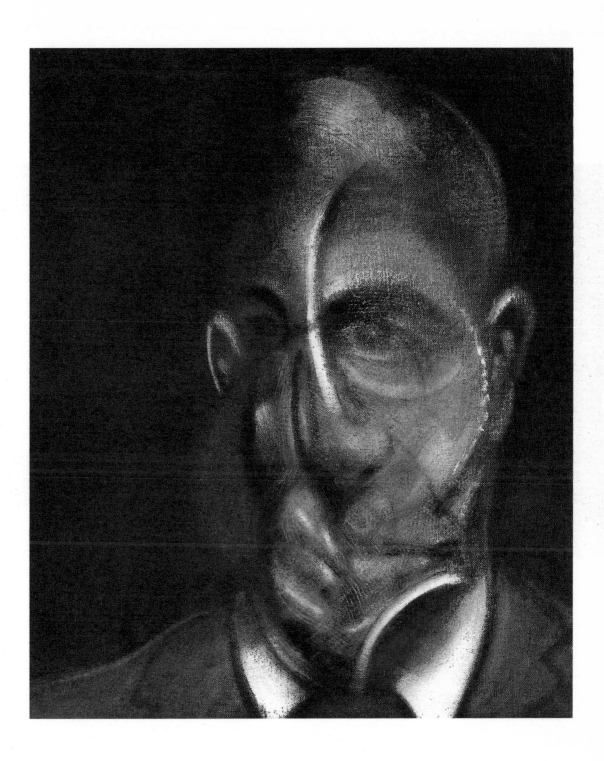

Portrait of Michel Leiris,
1976.
Oil on canvas,
14 × 12 in. (35.5 × 30.5 cm).
Musée National d'Art Moderne,
Centre Georges Pompidou,
Paris. Gift of Michel and
Louise Leiris.

A marked spatial break along one axis— generally the curve
of the nose or the arch of the eyebrows—is one of the typical
means employed in Bacon's portraits in order to disrupt the
features of a face. This is no doubt a lesson he learned from
the Picasso compositions of the twenties and thirties that
Bacon had first seen in his youth.

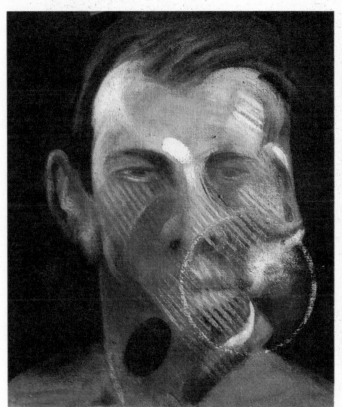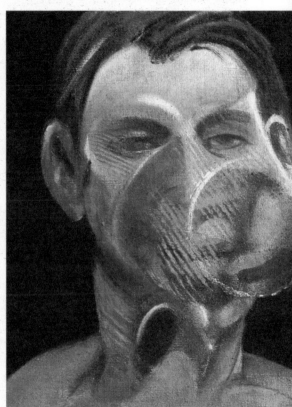

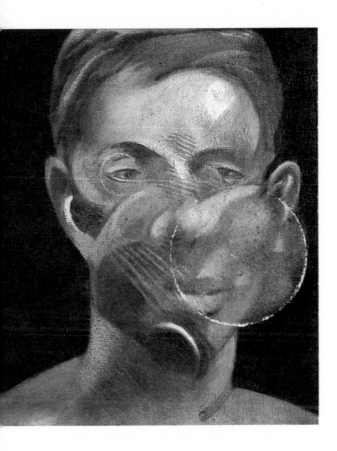

*Three Studies for a Portrait
(Peter Beard),* 1975.
Small triptych.
Oil on canvas; three panels,
each 14 × 12 in.
(35.5 × 30.5 cm).
Private collection, Madrid.

Beard was the most frequent model for the portraits completed
after the death of George Dyer. The circle superimposed on a part
of the face is here also a means to distort its mass, as though
part of the jaw or cheek were seen through a magnifying glass.
These enlarged details probe the person's physical presence.

In conversation, however, Bacon usually disavows any disposition favoring a particular subject matter or symbolism. He discusses content and form matter-of-factly, primarily in terms of sensation and technical problems. When critics wrote that his early shows exemplified the postwar mood of despair, under the influence of Surrealism and Existentialism, *Time* magazine quoted him as follows: "Horrible or not, said Bacon, his pictures were not supposed to mean a thing. '…Painting is the pattern of one's own nervous system being projected on canvas.'"[9] Regarding his early obsession with the human mouth and primal scream, he denies any intention of trying to terrorize or shock his viewers:

> People say that these [open mouths] have all sorts of sexual implications, and I was always very obsessed by the actual appearance of the mouth and teeth, and perhaps I have lost that obsession now, but it was a very strong thing at one time… I've always hoped in a sense to be able to paint the mouth like Monet painted a sunset.[10]

Although Bacon steadfastly insists that he does not set out to paint scary or even enigmatic pictures, he does not deny holding a fatalistic view of existence. He considers his philosophy a demonstrable or, perhaps more accurately, an obligatory form of modern realism for the honest observer willing to examine the ways of the world. He acknowledges that his paintings are difficult and that they place serious demands on their audience because they strip away our more optimistic illusions and compel us to shed our habits of belief in the shallow euphemisms of a glittering consumer culture.

His abiding concern for the irrational is evident in his imagery of the abnormal and the impaired, underscoring a darker view of a humanity only partially evolved from an ignoble, animal condition. Thus, his studies after Muybridge, notably the *Study for Crouching Nude*, 1952 (p. 20), and the more explicit and fully realized *Paralytic Child Walking on All Fours (from Muybridge)*, 1961 (p. 48), are examples of the artist's talent for reducing man to an ignominious animal state suggesting an evolutionary regression. Dawn Ades and the critic Gilles Deleuze have described these transformations as a form of truth telling about the human condition and even suggested that they show a special sensitivity to animal life by elevating the beast rather than "lowering" man to the level of the beast.[11] A perhaps more persuasive and reasonable interpretation is suggested by the psychologist Bruno Bettelheim in a fascinating discussion of partially animalized children. He describes the malformed or half animal, half human creatures of folk myth as fantasy projections of parental rage or discord, a condition that is usually corrected in the benevolent, stereotypical fairy tale resolution with the restoration of positive feeling for the child on the part of the parents. "In fairy tales and dreams," he writes, "physical malformation often stands for psychological misdevelopment."[12]

Bacon's pessimistic philosophy also makes connection with the gallows humor, the *humour noir*, of so much modern literature bred in the emotional climate of World War II, among which he particularly admires the prose of Samuel Beckett and Harold Pinter. Like these severe but tonic writers, Bacon feels his art represents the simple unalloyed truth of existence as he perceives it, no matter how hard to bear that reality may be. For him, the philosophical Existentialists and their literary followers set the tone with their perception that the basic problems of existence were loneliness, the impenetrable mystery of the universe, and death. Basically, Bacon believes in a form

. . .

9 Quoted in Davies and Yard, *Francis Bacon*, p. 21.

10 David Sylvester, *The Brutality of Fact: Interviews with Francis Bacon*, 3rd ed. (London and New York: Thames and Hudson, 1987), pp. 48–50.

11 See Ades, "Web of Images," and Gilles Deleuze, *Francis Bacon: Logique de la sensation* (Paris: Éditions de la Différence, 1981).

12 Bruno Bettelheim, *The Uses of Enchantment, The Meanings and Importance of Fairy Tales* (New York: Knopf, 1976; London: Thames and Hudson, 1979), p. 70.

of the philosopher Friedrich Nietzsche's nihilism and certainly, too, in the aspect of the Greek ideal that Nietzsche so enthusiastically endorsed, the Dionysian conquest of pessimism through art. In the sixties Bacon named one of his most harrowing triptychs, a three panel excursion into a phantasmagoria of bloody murder and mayhem that was based on an actual crime of sensational character, after Eliot's poem "*Sweeney Agonistes*", 1932 (pp.72-73). The poem contains the daunting refrain: "that's all the facts when you come to brass tacks:/Birth, and copulation, and death."[13] The Eliot reference recalls a similar sentiment of disenchantment regarding the futility of existence expressed by Nietzsche in a dialogue in *The Birth of Tragedy*, 1872. When Midas asked Silenus what fate is best for man, Silenus answered: "Pitiful race of a day, children of accidents and sorrow, why do you force me to say what were better left unheard? The best of all is unobtainable—not to be born, to be nothing. The second best is to die early."[14] Another leitmotif in Bacon's painting besides the vanity of existence was stated as early as 1944 in *Three Studies for Figures at the Base of a Crucifixion* (pp. 8-9), and it has been reaffirmed in some of his masterful triptychs of the eighties: the Greek theme of nemesis. More explicitly, his imagery involves the myth of the pursuit of Oedipus and Orestes by the Furies for their different heinous crimes of patricide, incest, and matricide. To frame the two myths in updated Freudian terms, Bacon evokes the anguish of primal guilt. His private artistic demons are the self conscious modern version of the Greek Fates and Furies. "We are always hounding ourselves," he has said. "We've been made aware of this side of ourselves by Freud, whether or not his ideas worked therapeutically."[15] He believes that for the authentic and incorruptible artist, impervious to social hypocrisy, the only available transcendence from man's poignant and vulnerable condition is achieved through the experience of art. As Nietzsche put it with a finality that would have pleased Bacon, "It is only as an esthetic phenomenon that existence and the world appear justified."[16]

In a masterpiece of the eighties Bacon dealt with the dark events of the Oresteia myth. *Triptych Inspired by the Oresteia of Aeschylus*, 1981 (pp. 86-87), is one of his most condensed and austere inventions, representing the Baconian equivalent of the tragic agon in three panels of powerfully condensed, hypnotic imagery. At left, the haunting and obscene symbol of the Erinyes, the Furies that relentlessly pursued a hallucinating Orestes for the murder of his mother, Clytemnestra, dangles like an obscene bat like creature in a cage structure. Although the action isn't specifically bound to a particular scene in the Aeschylus trilogy, the central panel suggests the contorted figure of the foully murdered Agamemnon, focusing on his spinal structure and jaw in the frontal plane, as if seen in x ray vision. The ceremonial dais and a schematic throne can be read as the high position of the king who met his death at the hands of the queen mother, out of vengeance for his own sacrificial murder of their daughter Iphigenia.

The third panel evokes both victim and oppressor and may stand for the tragic hero Orestes as well as the undefined shapes and darkness of unformed life (the elan vital or libido), lifting the chilling painting to an even higher level of allegorical meaning. This inspired paraphrase of the action and possible modern applications of Greek tragedy translates into the recognizable Surrealist forms of metamorphosis and interiorized imagery. The half playful inventions of Surrealist fantasy achieve a deeper and more serious content, however, by tapping into ancient sources in myth, ritual, and a theatrical form that reveals its meanings more

· · ·

13 T. S. Eliot, "Sweeney Agonistes," in *Collected Poems 1909-1935* (London: Faber and Faber, 1936; New York: Harcourt, Brace and Company, 1936), p. 147.

14 Friedrich Nietzsche, "The Birth of Tragedy out of the Spirit of Music," in Will Durant, *The Story of Philosophy* (New York: Simon and Schuster, 1953), p. 306.

15 Bacon, interview by Davies, September 7, 1983, in Davies and Yard, *Francis Bacon*, p. 102.

16 Nietzsche, *Birth of Tragedy*, in Durant, p. 306.

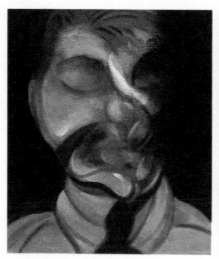 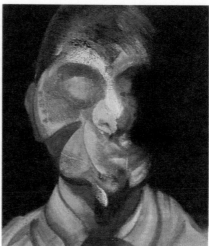 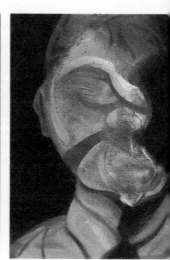

Self-Portraits

Although they are less renowned than his paintings of his intimate
circle, Bacon frequently made portraits of himself. His series of
self-portraits can be understood almost as a pictorial diary, but
they show the same curious mixture of cold objectivity and intense
immediacy as in his paintings of his friends. The method is, of
course, the same as in the other portraits, dislocating the features
by pulling them around the face's central axis. However great this
distortion becomes, Bacon's subjects remain recognizable.
Representation is pushed to that ambiguous moment when presence
seems about to dissolve, but has not yet completely lost its
distinguishing features.

*Three Studies for a
Self-Portrait*, 1972.
Small triptych.
Oil on canvas; three panels,
each 14 × 12 in.
(35.5 × 30.5 cm).
Private collection.

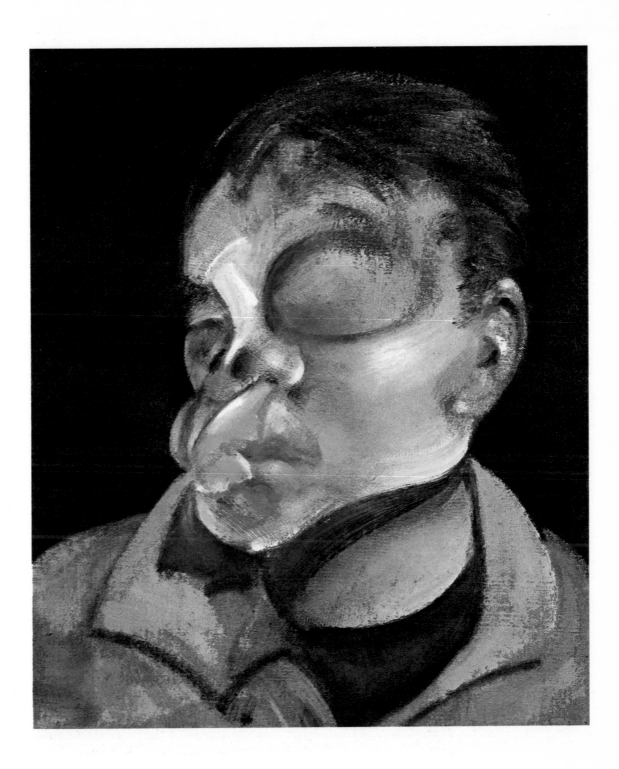

Three different aspects of the face are shown, but without changing the position of the head. Bacon employs only a few brusque marks—the blue and white strokes along the eye and nose, and the black zone of the cheek from which the viewer must recompose the image. All the features are concentrated in the right half of each face, with the other half consumed by shadow.

Self-Portrait with Injured Eye, 1972.
Oil on canvas, 14 × 12 in. (35.5 × 30.5 cm).
Private collection.

The inflamed eye serves as the basis for the deformation of the entire face, taking over one side completely and pushing the remaining features to the other side.

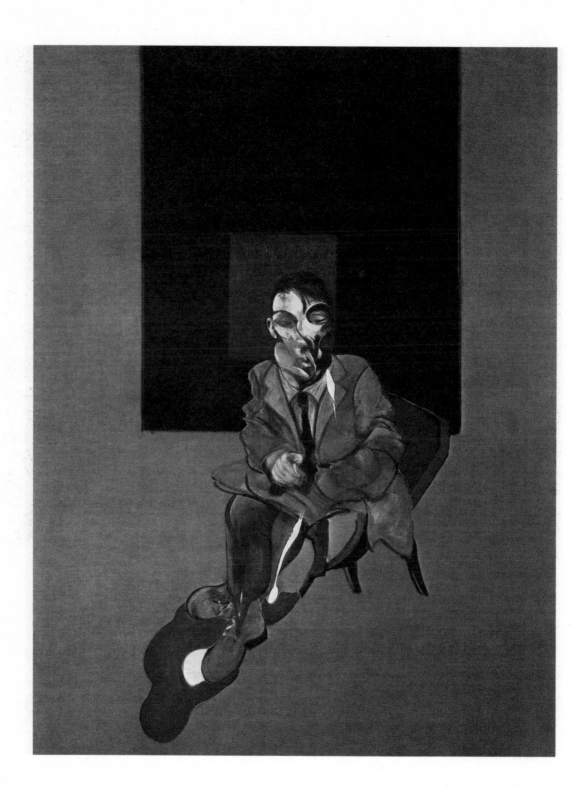

Self-Portrait, 1972.
Oil on canvas,
78 × 58 in. (198 × 147.5 cm).
Private collection.

Two views of the painter in spatial settings frequent in his works. In the first, space is reduced to the series of planes denoted by the differently colored rectangles. In the second, the curved back wall makes the space a cylinder, its floor filled with the typical accessories of the studio: the chair, table, light switch, and the newspaper on the floor.

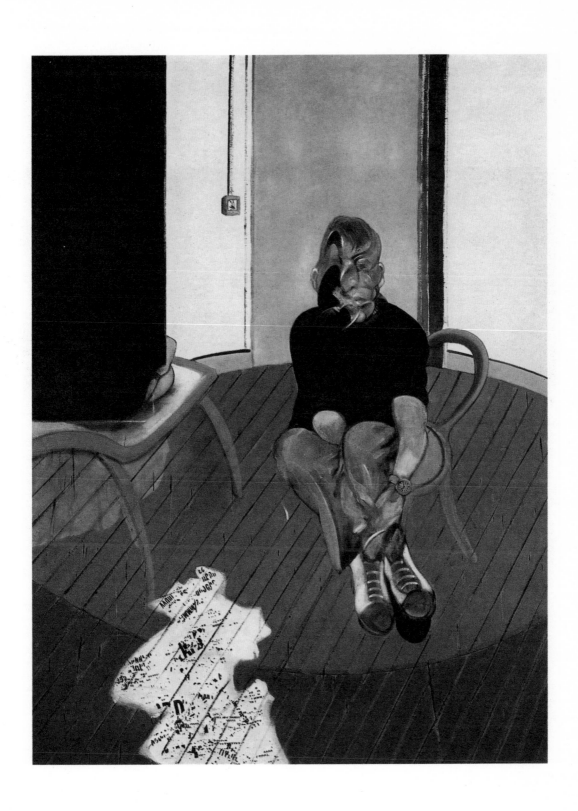

Self-Portrait, 1973.
Oil on canvas,
78 × 58 in. (198 × 147.5 cm).
Private Collection.

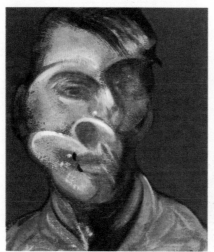 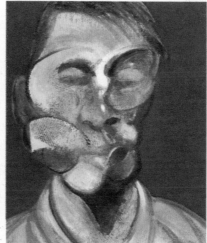 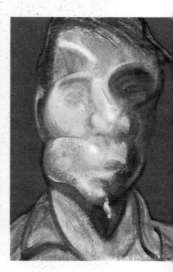

***Three Studies for a
Self-Portrait***, 1973.
Small triptych.
Oil on canvas; three panels,
each 14 × 12 in.
(35.5 × 30.5 cm).
Private collection.

Bacon again concentrates the features on one side of the face,
dislocating its symmetrical structure. The actual fingerprints
on the picture surface reveal the artist's direct manipulation
of the paint, as in a considerable number of his portraits. They
constitute the visible evidence of Bacon's physical engagement
with the pictorial material itself.

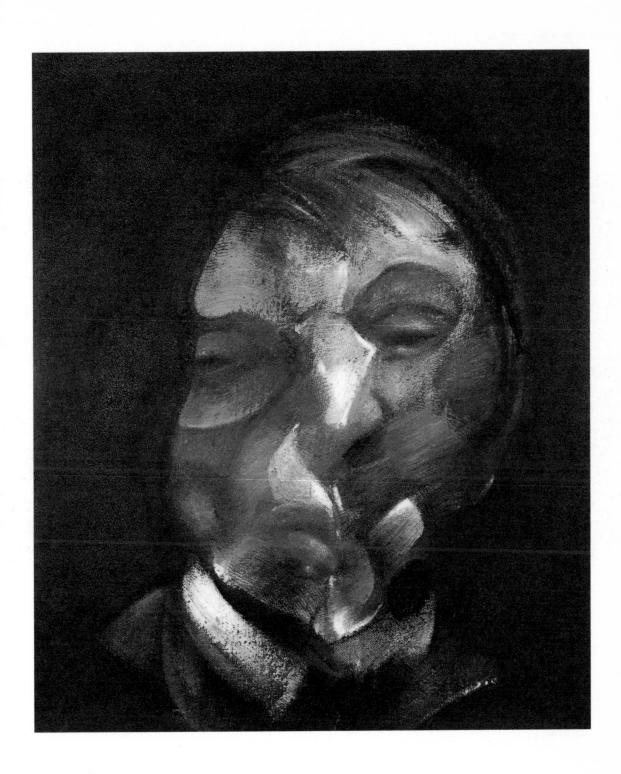

Self-Portrait, 1971.
Oil on canvas, 14 × 12 in.
(35.5 × 30.5 cm).
Musée National d'Art Moderne,
Centre Georges Pompidou,
Paris. Gift of Michel and
Louise Leiris.

This is perhaps the most painterly of Bacon's self-portraits:
the individual facial features are inseparable from the clearly
evident brushstrokes that depict them. The light, too, is
unusually pictorial: the countenance seems to emerge like a
spectral presence from the penumbra of the background.

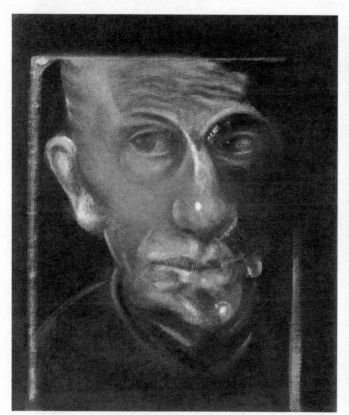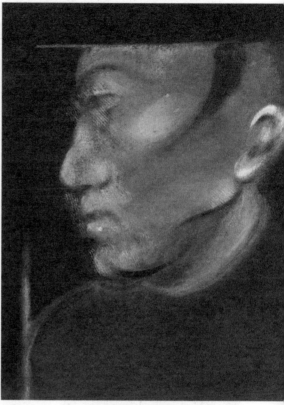

Two Studies for a Portrait of Richard Chopping, 1978.
Diptych.
Oil on canvas; two panels,
each 14 × 12 in.
(35.5 × 30.5 cm).
Private collection, Paris.

Although his most frequent
choice was the triptych,
Bacon's interest in the serial
image occasionally produced
double panels.

mysteriously, both in the paint action and through a dramatic theatrical setting. Bacon has told Hugh Davies, "If you talk about futility you have to be grand like Shakespeare's *Macbeth*…"[17] Davies concluded that Bacon attained significant grandeur and something more in a searing but high formal art that "reinvent[s]… what we know of our existente… tearing away the veils."[18] Despite Bacon's painfully testing imagery, his extraordinary figures and pictorial drama revive singular qualities in the art of our time, recreating modern man in the image of the formal grandeur and with the beauty of texture of the greatest Old Masters from Titian, Rembrandt, and Velázquez to Goya. Closer to our own time, works by Degas and Cézanne have also keenly engaged his interest. "Cézanne: The Early Years 1859-1872", an exhibition of that artist's curiously obsessive early paintings on view at the Royal Academy in London in the summer of 1988, riveted Bacon. He visited the show more than once, relishing the strangely unfinished, touching images of Cézanne's family and intimate circle of friends and his violently erotic inventions, with their fresh, contemporary spirit and vital handling. The combination of evident gaucherie and expressive power within a once-derided system of figuration that is now recognized as clearly original particularly moved Bacon. Some observers discovered unexpected affinities between the two artists, finding a bridge to Bacon in Cézanne's youthful compulsions, his rawness and aggression in paint handling, and "a lurid visual imagination which can shock even in the era of new expressionism," as the art historian John House described the revelatory show.[19]

Bacon respects art historical precedent, but risk and chance remain constants in his work, much as they figured in his biography, reflected particularly in his early compulsive gambling bouts, wanderlust, and unconventional life style. His dominant artistic concern has been to capture the instant of movement and life's ephemera before they lose their immediacy. At the same time, he feels that he is engaged in a constant battle, more often lost than won, between the potential expressiveness of the raw material of oil paint on its support and his own refined intention to achieve the visual equivalent of Flaubert's exacting "le mot juste."

Nonetheless, Bacon also paints with abandon, freely using rags and his hands as well as the brush. He is not beyond combining paint with random mixtures of the dust and crushed pastel that have accumulated on his rarely swept and untidy studio floor. He has always painted directly on canvas in a spontaneous and inspirational process of whipping and dragging pigment over the surface with brush or rags, or even flinging it onto the surface from a distance, often in a kind of ecstatic frenzy. His fierce emotional investment in his work, and the desperate all or nothing premium he places on expressive realization, however, give way to a secondary refining process and synthesis of formal structuring. Actually, it is inseparable in his mind from the original inspiration and helps him further clarify, focus, and build his repertory of images in their fascinating encounters and mutations.

In the late sixties especially Bacon contrived some of his most brilliant exercises in portraiture in repeated images of himself and some of his closest friends at that time (pp. 21, 25, 26-27, 30, 31, 43, 45, 52-53, 70-71). They are masterful evocations of a familiar cast of characters for those who know his oeuvre, not unlike Picasso's rapidly changing guard of favored mistresses who were recognizable models for his figure compositions and portraits of the late thirties and forties. For Bacon, these identifiable and named individuals represent an important break in his art, beginning with a small painting of Lucian Freud in 1951 and proceeding through his more complex portraits of George Dyer, John Edwards, Lucian Freud, Isabel Rawsthorne, and others from his intimate circle over the next three decades.

• • •

17 Bacon, interview by Davies, April 3 1983, in Davies and Yard, *Francis Bacon*, p. 102.

18 Bacon, interview by Davies, June 26, 1973, in Davies and Yard, *Francis Bacon*, p. 102.

19 John House, "The Work of Cézanne before He Became Cézanne," *New York Times*, June 5, 1988, sec. H, pp. 37-39.

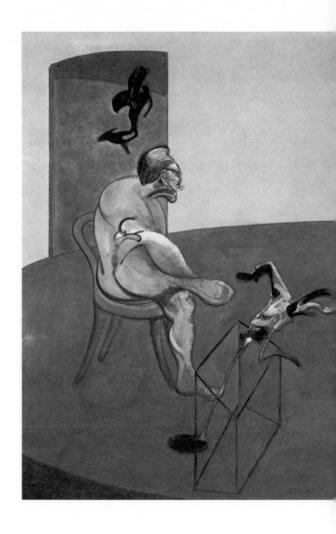

Triptychs

The idea of a theater that parts the curtain on the figure in its
most hidden intimacy culminates in the triptychs, the defining
format in Bacon's painting. His sequences of images possess a
sense not of narrative but rather of repetition. The fundamental
objective is to involve the viewer in a suggestive setting,
reinforcing the effect of the spatial boxes in which the figures
are placed. In the preparatory studies for faces in portraits,
Bacon used a smaller format clearly inspired by the frontal and
profile photographs typical of police mug shots; he also made
use of sequential snapshots taken by automatic photo booths.

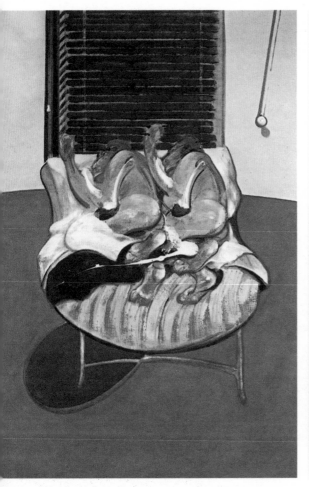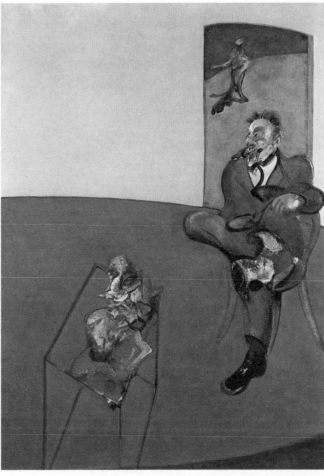

Two Figures Lying on a Bed with Attendants, 1968. Oil on canvas; three panels, each 78 × 58 in. (198 × 147.5 cm). Tehran Museum of Contemporary Art.

The three panels form one pictorial space and a single scene. The counterposed figures to the sides reinforce the doubling of the two figures on the bed.

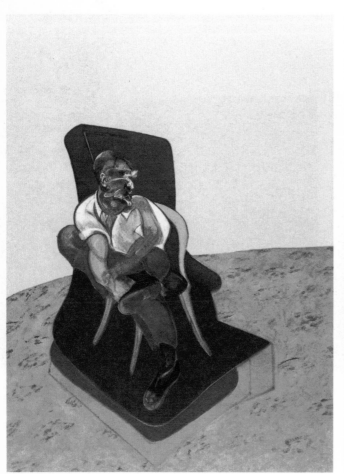
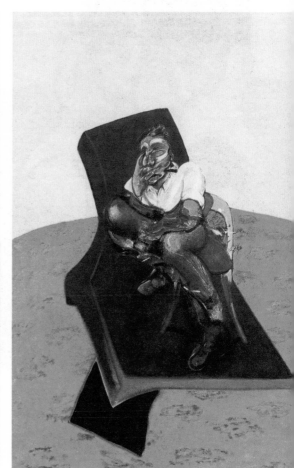

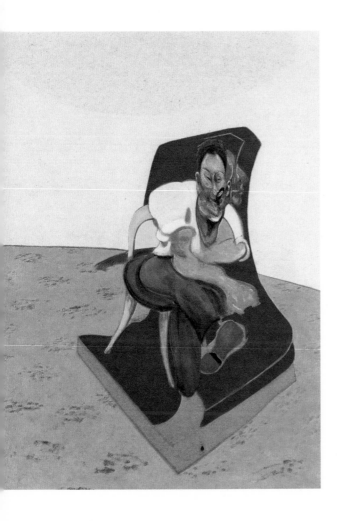

*Three Studies for a Portrait
of Lucian Freud*, 1966.
Oil on canvas; three panels,
each 78 × 58 in.
(198 × 147.5 cm).
Private collection.

Bacon disturbs the symmetry typical of the triptych format by
turning the figure in unexpected ways. Here, the frontal view of
the face appears in the right hand panel instead of in the central
one, with the two profiles paired at the left.

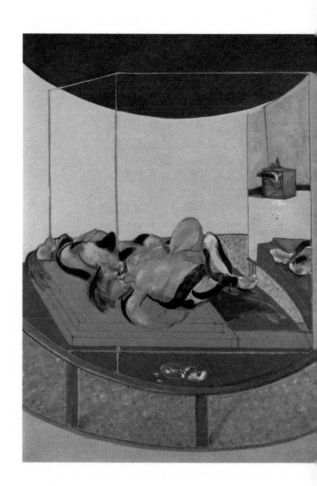

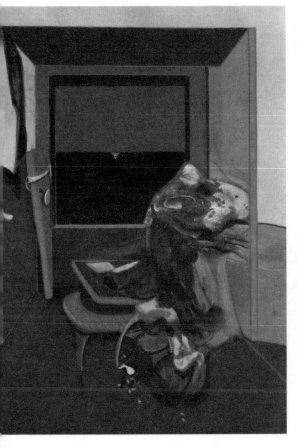
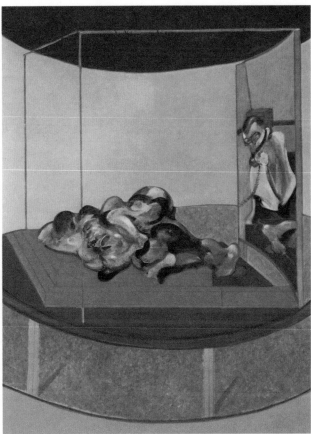

*Triptych inspired by T.S.
Eliot's Poem "Sweeney
Agonistes"*. 1967.
Oil and pastel on canvas,
each panel: 78 × 58 in.
(198 × 147.5 cm).
Hirshhorn Museum & Sculpture
Garden, Smithsonian
Institution, Washington, D.C.

On the one hand, this development allowed Bacon to shed what he perceived as an exhausted anonymity both in his isolated figures and allegorized representations of the antiheroic, contemporary Everyman, depicted as victim, persecutor, or mere witness to an age of violence. Instead, he created a more subtle and verifiable pictorial illusion of specific individuals from his own entourage. They seemed to afford him fresh access to equally compelling dramatic and expressive forms that could be appreciated less equivocally as a genre of modern realism. At the same time, he transcended the obvious limits of realism by endowing his still mysterious portrait figures with something of the same ceremonial dignity and tragic resonance found in his triptychs and narrative art.

In both genres an external force, translated into alternately wounding and obliterating paint marks, seems to erode the physical substance and, by inference, the very being of his dramatis personae. The self conscious stripping away of the social mask has been a major strategy of Bacon's truth telling art, although sitting for one of his uncanny portraits is such an intense and unnerving experience that he no longer works directly from his models. He prefers not to alienate his old friends or concern himself with their aghast responses, lest he inhibit the violence and freedom required for realizing his pictorial vision.

"'My ideal,' Bacon told David Sylvester [collaborator in the major collection of his interviews], 'would really be just to pick up a handful of paint and throw it at the canvas and hope that the portrait was there.'"[20] His gallery of portraits also recalls some of the great visceral images of Oskar Kokoschka and Egon Schiele, those Viennese antecedents in visionary Expressionist portraiture that was also calculated to unmask and bare the soul of the artist's uneasy sitter. Because working from the model made him uneasy but also from a fascination with the challenge of his own phenomenological persona, as it exists objectively in the world, Bacon has also focused strongly and repeatedly on the self-portrait. He has painted himself almost as often as he has his best friends. There was a certain practicality in turning to a cooperative model and also undoubted philosophical and formal rewards in keeping a visual record of the changing meanings of flesh depicted over time, with the inescapable test of resolute will and spirit implicit in that confrontation. *Study for Self Portrait—Triptych*, 1985-86, is his most ambitious recent study of this kind. The figure's hunched pose—legs crossed and arms hugging his knees—and precarious stance on a stool recall the coiled and tortured posture of his 1973 self-portrait (p. 63) and some of the body torsions of related portraits in the sixties and seventies of Dyer, Freud, and Rawsthorne. All these awkward, gratuitously demeaning poses echo a more distant crouching, animalized nude figure of 1952—the harrowing image of an apparently headless figure perched ape like on a curving rail (p. 20). The image was taken, and modified, from Muybridge's photograph, *Man Performing Standing Broad Jump*.

The extent of Bacon's irrational, but personally meaningful, translation of Muybridge's banal image has been described by Davies and Yard in a passage of rare candor. Their convincing interpretation once again underscores the deeper meanings of Bacon's metaphors and reconstructions of contemporary and historical visual sources. The "compact pose," they write, "ambiguously suggests the fetal position, the stance for defecation, and—as seen more clearly some twenty years later, in *Triptych May-June*, 1973 (pp. 78-79)—the position assumed in death."[21] That triptych presented with painful accuracy the physical circumstances of the suicide of Bacon's close friend George Dyer. The writers continue to explore the drama of Bacon's symbolism, providing the reader with an important bridge from the atrocious particulars of his imagery to its transcendent implications of familiar visual and moral lessons of the age:

• • •

20 Andrew Forge, "About Bacon," in *Francis Bacon,* exhibition catalogue (London: Tate Gallery and Thames and Hudson, 1985; New York: Abrams, 1985), p. 30.

21 Davies and Yard, *Francis Bacon,* p. 29.

Calling to mind naked men locked away in anonymous, windowless cells, this figure conveys the introspection, regression, and withdrawal associated with prison or asylum inmates, the quintessential posture of man divested of civilization.[22]

Dignity rather than degradation is the keystone of Bacon's more recent self-portraiture. The old smears and distortions of paint still exist in the 1985-86 triptych but with less vehemence or pressure on the human image. The action takes place in a more austere but benign environment against a simplified background, in this instance, the curved areas, painted white, that contrast with the expanse of unsized canvas. Few of the distracting tics or agitation of his freakish humanoid imagery of the past persist. Bacon's new figural paradigm is drawn from Egyptian sculpture of the Ptolemaic period.[23]

In a recent and rare non-figurative work, *Jet of Water*, 1988 (p. 49), however, Bacon continued his dogged tracking of the ephemeral and marvelous by literally emptying a bucket of grayed white paint on the upright canvas to simulate the violent spurt and flood of a powerful stream of murky water. Only through such play with chance, with its intense momentary truth, whether in the frozen human grimace or in a powerful water jet, can Bacon "unlock the valves of feeling and therefore return the onlooker to life more violently."[24] Spurning the illustrational side of realism, he says that the successful artist must connive to bait reality and "set a trap by which you hope to trap this living fact alive."[25]

Another recent painting, *Study for Portrait of John Edwards*, 1988, is one of a continuing series with his companion John Edwards as model. It dramatically illustrates Bacon's major pictorial premises, combining allusions to the heroic male nudes of the Italian Renaissance or, in a source closer to hand, the Elgin marbles in the British Museum, with the sense of human flesh as the mortal envelope we all bear and ultimately must slip. His depicted flesh is both ghoulish and strangely beautiful, touching a nerve as it declines into ectoplasmic nullity, swallowed by a vaguely sinister panel of black. Bacon has always concentrated on the flesh—in this instance, a roseate face, powerfully muscled torso, and limbs that extend themselves mysteriously into a puddle of nondescript shadow and paint.

Over the years Bacon has proved himself a voluptuary of the flesh, like Rubens, Watteau, or Soutine in their distinctly different ways, and in his later years, he seems most like the aging Rembrandt. Flesh is for him the essential material of being and of things, life's basic substance. Paint becomes flesh in its color, texture, material density, and fluidity—a vehicle that serves desire and rekindles art historical and personal memory, allowing him to discover the physical and spiritual particularity of a specific person. Perhaps in this limited sense he is a realist at heart, as some of his English colleagues have averred when they recently sought to link him with a self conscious London school that includes such devotees of figuration as Frank Auerbach, Lucian Freud, and R. B. Kitaj.[26] In *Study for Portrait of John Edwards* Bacon compresses his figure of Edwards into a kind of iridescent pigment skin where paint and depicted body gloriously fuse, pushing his warped figuration to a point near dissolution, not unlike the gorgeous sunsets of Monet that he tried to emulate in his disturbing early paintings of the papal scream.

Ever the wily magician in his manipulation of paint, Bacon has lost none of his touch or invention with the years. In his recent work he continues to bait the "trap" for capturing the distilled essence of reality, salvaging the mysterious living image of man from the ruins of time, as the great paintings of the past have done for the instruction and delectation of the privileged viewer.

· · ·

22 Ibid.

23 Bacon, interview by the author, June 22, 1988.

24 Sylvester, *The Brutality of Fact*, p. 17.

25 Ibid., p. 57.

26 Michael Peppiatt, "Could There Be a School of London?" and "Francis Bacon: Reality Conveyed by a Lie," *Art International* (Paris) I (Autumn 1987): pp. 7-21 and 30-33.

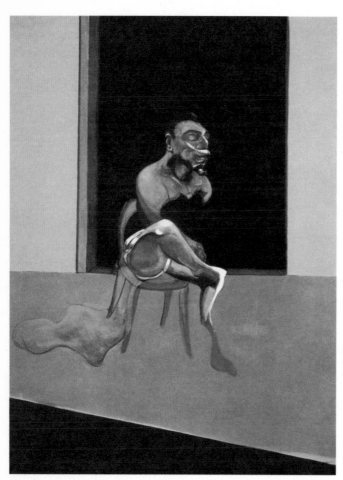
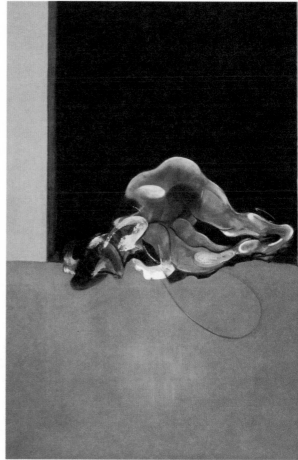

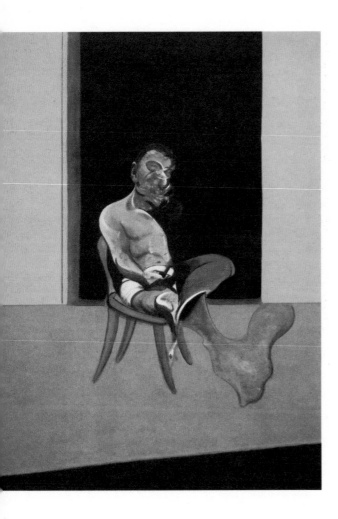

Triptych, August, 1972.
Oil on canvas; three panels,
each 78 × 58 in.
(198 × 147.5 cm).
Tate Gallery, London.

The three panels create a space subtly disturbed in its
symmetry: there is a door in each panel, but of different size;
and the scenes in the side panels are turned at slightly
different angles with respect to the plane of the central
canvas. The contrast between the bare, antiseptic setting and
the mutilated figures produces an intensely dramatic effect
with great sobriety of means.

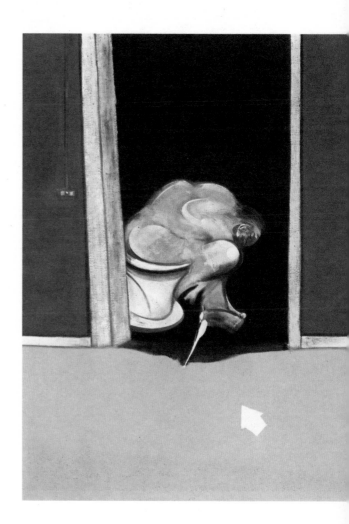

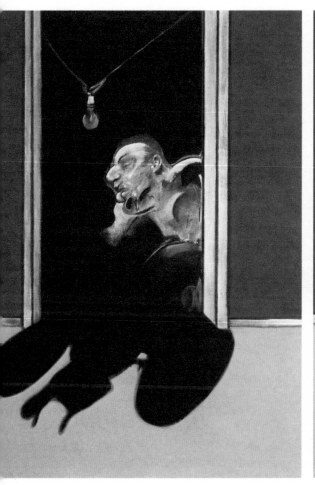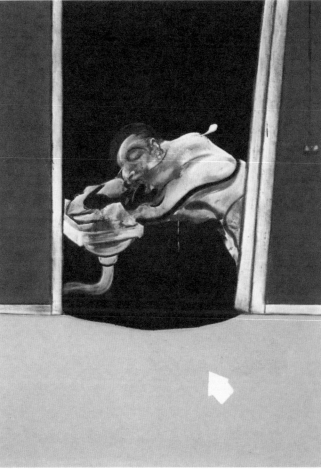

Triptych, May June 1973,
1973.
Oil on canvas; three panels,
each 78 × 58 in.
(198 × 147.5 cm).
Private collection.

In this triptych the painter
alludes to the circumstances
of the suicide two years
earlier of his friend George
Dyer with horrifying precision.
Yet the solemn harmony of
purple and black lends the
composition an unexpected
ceremonial dignity.

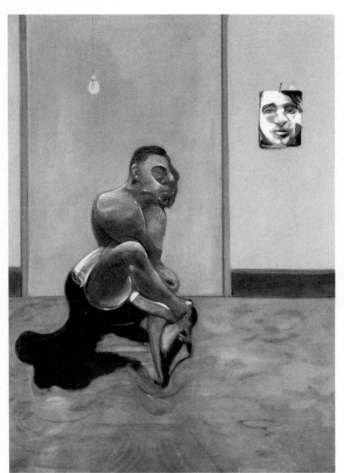
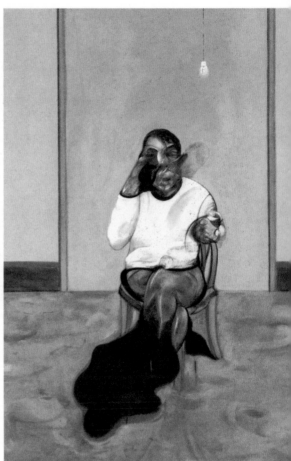

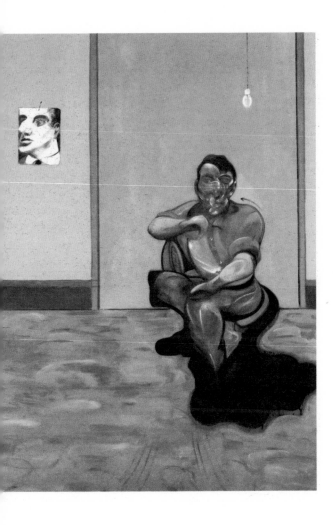

*Three Portraits: Posthumous
Portrait of George Dyer,
Self-Portrait, and Portrait of
Lucian Freud*, 1973.
Oil on canvas; three panels,
each 78 × 58 in.
(198 × 147.5 cm).
Galerie Beyeler, Basel.

The triptych format holds for
Bacon a certain power of
ritual evocation. This is seen
in the encounter between his
own image and those of two of
his closest friends, one of
them—George Dyer—already
dead at that time.

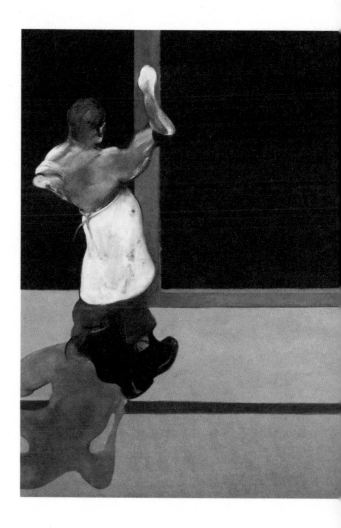

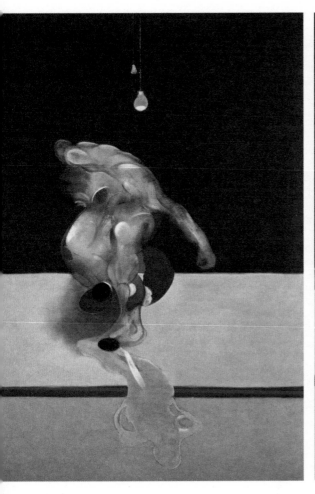
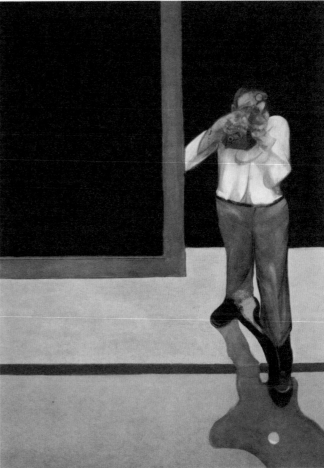

Triptych, March 1974, 1974.
Oil on canvas; three panels,
each 78 × 58 in.
(198 × 147.5 cm).
Private collection, Madrid.

The figure in the central panel derives, once again, from
Muybridge's photographs. The figures on the side panels open
and close the composition: one, facing away, looks into the
canvas, while the other—the photographer who seems to direct
his camera lens toward the viewer—looks out from it. Both
clothed figures contrast with the nude figure in the center
panel and reinforce the immediacy of its presence.

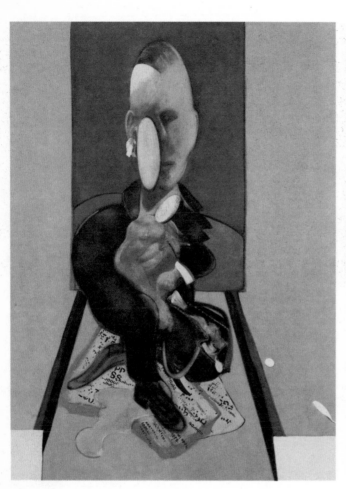
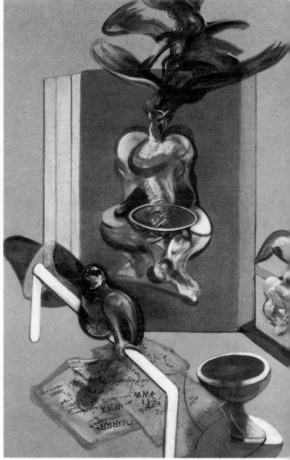

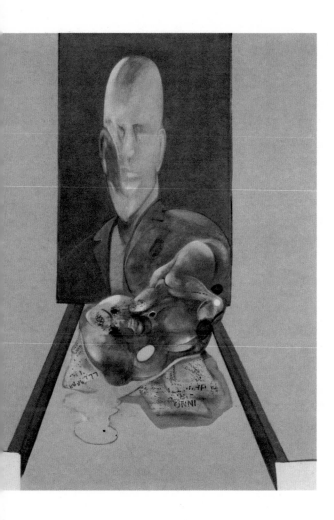

Triptych, 1976.
Oil and pastel on canvas;
three panels, each 78 × 58 in.
(198 × 147.5 cm).
Private collection.

These apparently arbitrary collections of images and diverse
objects bear some resemblance to the dream logic of Surrealism,
although they all in fact belong to Bacon's established
repertoire: nude figures in tension, skeletal anatomies
attacked by birds of prey, and so on. Everything seems to
converge on the bloody ceremony depicted in the central panel,
a ritual that the portrait busts on the side panels attend
indifferently, like sphinxes—the guardians of a secret.

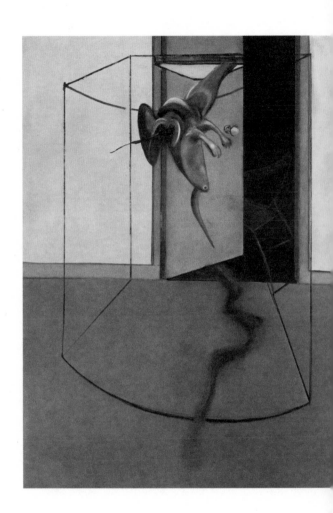

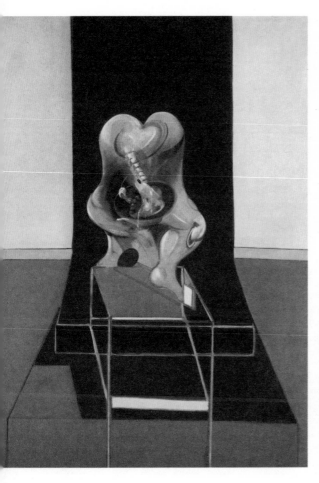
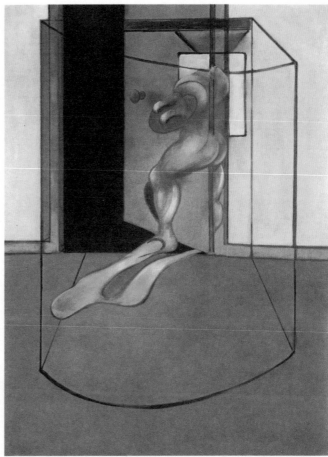

Triptych Inspired by the
Oresteia of Aeschylus. 1981.
Oil on canvas, each panel:
78 × 58 in. (198 × 147.5 cm).
Astrup Fearnley Museet for
Moderne Kunst, Oslo.

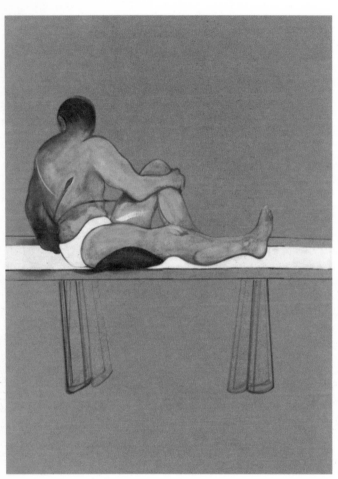
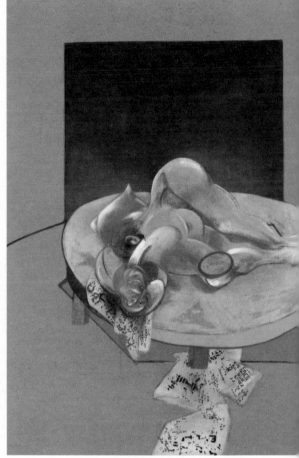

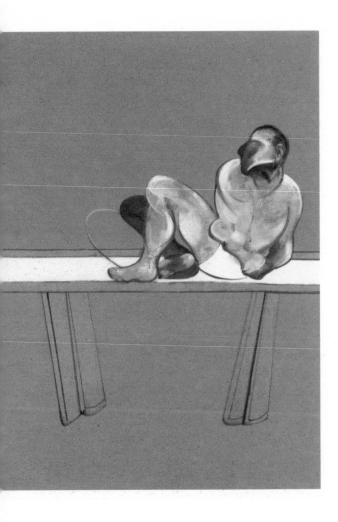

Triptych: Studies from the Human Body, 1979
Oil on canvas; three panels,
each 78 × 58 in.
(198 × 147.5 cm).
Private collection.

The influences of Michelangelo and Muybridge, two of the
presiding spirits in Bacon's works, are overtly combined in this
canvas. The side figures are related to Michelangelo's funerary
sculptures for the Medici Chapel in Florence. The central pair
is, in turn, another version of Muybridge's wrestlers.

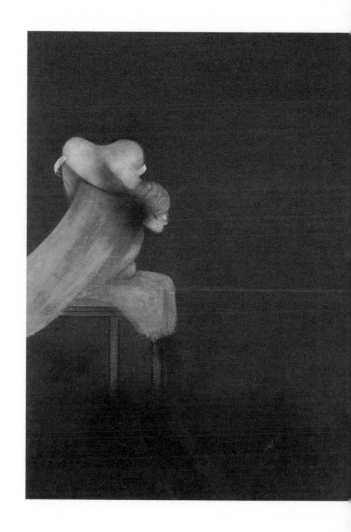

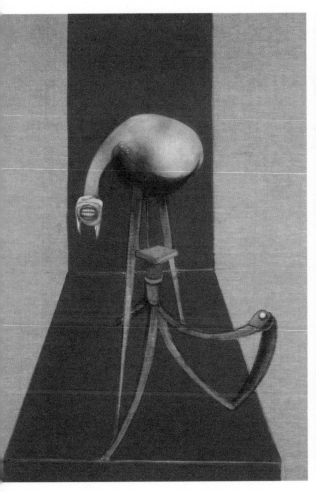
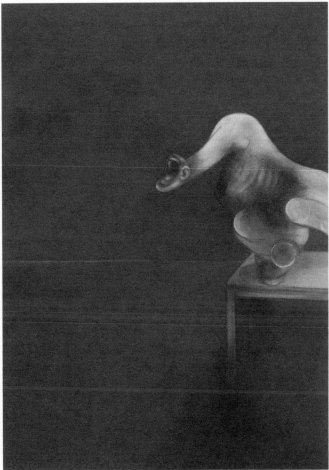

Second Version of "Triptych 1944", 1988.
Oil on canvas; three panels, each 78 × 58 in.
(198 × 147.5 cm).
Tate Gallery, London.

Bacon here returns to one of his signature images, painting a second version of the Crucifixion that in 1944 had established the format of the triptych in his work. The blind, bulbous figures are essentially the same, two having appendages that end in open mouths. What is different is the space in which they are placed, especially in the central panel, and the treatment of color, now darkly contrasting and more solemn, even elegiac.

Chronology

1909

Born in Dublin, 28 October, of English parents, the second of five children. Father a breeder and trainer of racehorses. He is a collateral descendant of the famous Elizabethan philosopher, Francis Bacon.

1914

At the outbreak of war, the family moves to London and his father joins the War Office. Thereafter they move back and forth between England and Ireland, changing houses every year or two—never having a permanent home.

1925

Bacon suffers from asthma as a child and is privately tutored—never has any schooling in the conventional sense. Leaves home at the age of 16 to go to London. Works for a short time as a servant to a solicitor and, later in an office for several months.

1927-1928

Travels to Berlin, stays for two months only, then on to Paris where he occasionally secures commissions for interior decoration. Visits a Picasso exhibition at the Paul Rosenberg Gallery which greatly impresses him and inspires him to start making drawings and watercolours.

1929

Returns to London. Exhibits in his Queensbury Mews studio furniture and rugs made from his own designs. Begins painting in oils (self-taught).

1930

Arranges a joint exhibition in his studio with Roy de Maistre, showing furniture as well as paintings and gouaches. The Studio magazine features a double-page article on his studio entitled "The 1930 Look in British Decoration".

1931

Moves to the Fulham Road. Gradually abandons his work as a decorator in order to devote himself to painting. Earns his living by doing odd jobs, none of them connected with art.

1933

Paints *Crucifixion 1933*, which is reproduced in Herbert Read's *Art Now*.

1936

Submits some work to the International Surrealist Exhibition. It is rejected as "not sufficiently surreal".

1937

Takes part in an important group exhibition, "Young British Painters", at Agnews, London, organized by his friend Eric Hall. Other artists include Roy de Maistre, Graham Sutherland, Victor Pasmore and Ivon Hitchens.

1941-1944

Moves for a short time to a cottage in Petersfield, Hampshire. Returns to London and rents Millais's old studio in Kensington. Destroys nearly all his earlier works (only ten canvases remain from the period 1929-44). Declared unfit for military service because of his asthma, is assigned to Civil Defense (ARP).

1944-1945

Resumes painting in earnest and executes the triptych *Three Studies for Figures at the Base of a Crucifixion*, which causes considerable consternation when shown at the Lefevre Gallery in April 1945. The mysterious forms were regarded as freaks; monsters irrelevant to the concerns of the day, and the product of an imagination so eccentric as not to count in any permanent way. The triptych is acquired by the Tate Gallery in 1953.

1945-1946

Exhibits *Figure in a Landscape* and *Figure Study II* in group exhibitions held at the Lefevre and Redfern Galleries. Other artists include Matthew Smith, Henry Moore and Graham Sutherland.

1946-1950

Lives mainly in Montecarlo. Friendship with Graham Sutherland.

1948

Alfred H. Barr purchases *Painting 1946*, one of his most important works, for the Museum of Modern Art, New York.

1949

One-man show at the Hanover Gallery, London, who become his agents for the next ten years. Begins painting the series of Heads (including *Head VI*, which is regarded as the first of the "Pope" paintings and *Head IV (Man with Monkey)*. Uses Eadweard Muybridge's photographic studies *Animal Locomotion* and *Human Figure in Motion* as a source of reference for his paintings of animals and the human figure.

1950

Teaches briefly at the Royal College of Art as deputy for John Minton. Travels to South Africa to visit his mother; spends a few days in Cairo.

1951-1955

Changes studios several times.

1953

First one-man show outside Britain at Durlacher Brothers, New York. Paints *Two Figures (The Wrestlers)*, considered by many as one of his greatest paintings.

1954

Paints the "Man in Blue" series. Together with Ben Nicholson and Lucian Freud, represents Great Britain at the XXVII Venice Biennale. Takes opportunity to visit Ostia and Rome but does not attend the Biennale or see the Velázquez portrait of Pope Innocent X, the reproduction of which inspired his series of "Popes".

1955

First retrospective exhibition at the Institute of Contemporary Arts, London. Paints portraits of the collectors Robert and Lisa Sainsbury, who become his patrons.

1956

Visits Tangier to see his friend Peter Lacey. Rents a flat and returns there frequently during the next three years.

1957

First exhibition in Paris, at the Galerie Rive Droite. Exhibits the Van Gogh Series at the Hanover Gallery, London.

1958

First one-man exhibitions in Italy; shows in Turin, Milan and Rome. Signs contract with Marlborough Fine Art Ltd., London.

1959

Exhibition at the V São Paulo Biennale. Paints for a while in St. Ives, Cornwall.

1960

First exhibition at Marlborough Fine Art, London.

1962

Paints his first large triptych, *Three Studies for a Crucifixion*, acquired by the Solomon R. Guggenheim Museum, New York. Major retrospective exhibition at the Tate Gallery, London. Modified version shown in Mannheim, Turin and Zurich (1963). Death of Peter Lacey.

1963-1964

Retrospective exhibition at the Solomon R. Guggenheim Museum, New York, and, afterwards, at the Art Institute of Chicago.

1964

Friendship with George Dyer, who becomes a model for many of his paintings. Executes large triptych, *3 Figures in a Room*, acquired by the Musée National d'Art Moderne, Paris.

1965

Paints large *Crucifixion* triptych, acquired by Munich Museum.

1966

Awarded the Rubens Prize by the City of Siegen. Exhibits at the Galerie Maeght, Paris. The artist attends the opening. The exhibition travels to Marlborough Fine Art, London (1967).

1967

Awarded the Painting Prize at the 1967 Pittsburgh International.

1968

Short visit to New York for exhibition of his recent paintings at the Marlborough-Gerson Gallery.

1971-1972

Important retrospective exhibition at the Grand Palais, Paris; subsequently shown at the Kunsthalle, Dusseldorf. Death in Paris of his friend and model George Dyer (1971). Paints large *Triptych 1972* in his memory.

1975

Travels to New York to attend opening of his major exhibition at the Metropolitan Museum of Art.

1977

Visits Paris for private view of his Exhibition at Galerie Claude Bernard.

1978

Brief visit to Rome to meet Balthus at the Villa Medici.

1980

The Tate Gallery acquires *Triptych-August 1972*.

1984

Short visit to New York for his exhibition of recent work at Marlborough Gallery.

1985-1986

Second retrospective exhibition at the Tate Gallery (125 works), which travels to Staatsgalerie Stuttgart and Nationalgalerie Berlin. Visits Berlin with his friend John Edwards. Paints large self-portrait triptych.

1987

Lives and works in London—with occasional visits to France. Exhibitions at Galerie Lelong in Paris and Galerie Heyder in Basel. Selection of paintings of the 1980s, including the Oresteia triptych, shown at the Marlborough Gallery, New York.

1988

Twenty-two paintings exhibited at the Central House of Artists in the New Tretjakoy in Moscow. Asthma prevents the artist from attending the opening.

1989

Second Version of *Triptych, 1944*, painted in 1988, exhibited in "Auerbach, Bacon, Kitaj" exhibition at Marlborough Fine Art in London.

1991

Paints *Study from the Human Body*, using John Edwards as model.

1992

Dies of heart failure during a vacation in Madrid.

Bibliography

MONOGRAPHS

Alley, Ronald, and John Rothenstein, *Francis Bacon: Catalogue raisonné* (London: Thames & Hudson and New York: Viking Press, 1964).

Alphen, Ernst van, *Francis Bacon and the Loss of Self* (London: Reaktion Books Ltd., 1992).

Anzieu, Didier, and Michele Monjauze, *Francis Bacon ou le portrait de l'homme désespéré* (Vevey: L'Aire and Paris: Archimbaud, 1993).

Anzieu, Didier, 'La peau, la mère et le miroir dans les tableaux de Francis Bacon', *Le corps de l'Œuvre* (Paris: Gallimard, 1981), pp. 333-39.

Archimbaud, Michel (ed.), *Bacon: Portraits and Self-Portraits* (London and New York: Thames & Hudson, 1996). Essays by Milan Kundera ('The Painter's Brutal Gesture', pp. 8-18) and France Borel ('Francis Bacon: The Face Flayed', pp. 187-202.

Baldassari, Anne, *Bacon Picasso: The Life of Images* (Paris: Musée Picasso, 2005).

Brighton, Andrew, *Francis Bacon* (London: Tate Gallery, 2001).

Calhoun, Alice Ann, *Suspended Projections: Religious Roles and Adaptable Myths in John Hawkes's Novels, Francis Bacon's Paintings and Ingmar Bergman's Films*, PhD dissertation, University of South Carolina, 1979 (Ann Arbor: University of South Carolina, Microfilm International, 1979).

Cappock, Margarita, *Francis Bacon's Studio* (London: Merrell, 2005).

Charras, Pierre, *Francis Bacon: Le ring de la douleur* (Paris: Ramsay/Archimbaud, 1996).

Dagen, Philippe, *Francis Bacon* (Paris: Cercle d'Art, 1996).

Davies, Hugh Marlais, *Francis Bacon: The Early and Middle Years, 1928-1958*, PhD dissertation, Princeton University, 1975 (New York and London: Garland Publishing Inc., 1978).

Davies, Hugh M., and Sally Yard, *Bacon* (New York: Abbeville Press, 1986).

Deacon, David Thomas, *The Nature and Development of the Theme- Form Violation within Containment in Harold Pinter's Plays and Francis Bacon's Paintings*, PhD dissertation, Ohio University, 1982 (Dissertation Abstracts International, no. DA8221887).

Deleuze, Gilles, *Francis Bacon: Logique de la sensation* (Paris: Éditions de la Différence, 1981; revised edition 1984). English trans.: *Francis Bacon: The Logic of Sensation* (New York: Portmanteau Press, 1992; London: Continuum, 2003).

Domino, Christophe, *Francis Bacon* (Paris: Gallimard and Centre Georges Pompidou, 1996). English trans.: *Francis Bacon: 'Taking Reality by Surprise'* (London: Thames & Hudson, 1997); and *Francis Bacon: Painter of a Dark Vision* (New York: Harry N. Abrams, 1997).

Dückers, Alexander, *Francis Bacon: 'Painting 1946'* (Stuttgart: Philipp Reclam Jr., 1971).

Farson, Daniel, *The Gilded-Gutter Life of Francis Bacon* (London: Century and New York: Pantheon Books, 1993; Vintage, 1994); French trans.: *Francis Bacon, aspects d'une vie* (Paris: Le Promeneur, Gallimard, 1994).

Ficacci, Luigi, *Francis Bacon 1909-1992* (Cologne and London: Taschen, 2003).

Fusini, Nadia, *B & B* (Milan: Garzanti, 1994).

Goyens de Heusch, Serge, *Francis Bacon: Un Génie Nietzschéen des profondeurs* [s.l., s.n.], 1980.

Guin, Pierre, et al., *Une œuvre de Bacon* (Marseille: Muntaner, 2000).

Harnmer, Martin, *Bacon and Sutherland* (London: Yale University Press, 2005).

Harrison, Martin, *In Camera: Francis Bacon: Photography, Film and the Practice of Painting* (London: Thames & Hudson, 2005).

James, N. P. et.al., 'Francis Bacon seminar: a discussion of the artist', cv/Visual Arts Research, no. 31, 2004.

Leclercq, Stéfan, *L'expérience du mouvement dans la peinture de Francis Bacon* (Paris: L'Harmattan, 2002).

Leiris, Michel, *Francis Bacon, ou la vérité criante* (Montpellier: Fata Morgana/Scholies, 1974).

Leiris, Michel, *Francis Bacon, Full Face and in Profile* (Barcelona: Ediciones Polígrafa, 1983; revised edition: Ediciones Polígrafa, 2008).

Leiris, Michel, *Francis Bacon ou la brutalité du fait* (Paris: L'Ecole des lettres/Seuil, 1995).

Micheli, Mario de, *Il Disagio Delta Civilta e le Immagini: Bacon, Giacometti, Cremonini, Ipousteguy* (Milan: Jaca Book, 1982).

Monsel, Philippe (ed.), *Bacon 1909-1992* (Paris: Cercle d'Art, 1994).

Nixon, John William, 'Francis Bacon, Paintings 1959-1979: Opposites and Structural Rationalism', PhD dissertation, Ulster: University of Ulster, 1986.

Nogueira, Luís Carlos, 'Francis Bacon: Corpos, Esgares e Silêncios. Ensaio-surnário', PhD dissertation, Covilha: Universidade de Beira Interior, 1999.

Peppiatt, Michael, *Francis Bacon: Anatomy of an Enigma* (London: Weidenfeld & Nicholson, 1996; New York: Farrar, Straus & Giroux, 1997; Barcelona: Editorial Gedisa, 1999; Cologne: DuMont Buchverlag, 2000; Paris: Flammarion, 2004; Tokyo: Shinchosha, 2004).

Peppiatt, Michael, *Entretiens avec Francis Bacon* (Paris: L'Échoppe, 1998).

Peppiatt, Michael, *Francis Bacon à l'atelier* (Paris: L'Échoppe, 1999).

Peppiatt, Michael, *Le regard de Bacon* (Paris: L'Échoppe, 2004)

Peppiatt, Michael, *L'amitié Leiris Bacon: une étrange fascination* (Paris: L'Échoppe, 2006).

Rothenstein, John, *Francis Bacon* (Milan: Fratelli Fabbri Editori, 1963; London: Purnell and Sons, Coll. The Masters, no. 71; Paris: Hachette, 1967).

Russell, John, *Francis Bacon* (London: Methuen and Co. Coll. Art in Progress, 1964).

Russell, John, *Francis Bacon* (London: Thames and Hudson; Greenwich, Connecticut: New York Graphic Society; Paris: Les Éditions du Chêne; Berlin: Propylaen Verlag, 1971. Revised edition: London: Thames and Hudson, Coll. World of Art Series, 1979; New York: Oxford University Press, Coll. World of Art, 1985. Revised and updated, London 1993; Paris 1994).

Schilling, Jürgen, *Études pour un portrait de Van Gogh par Francis Bacon* (Paris: Éditions de la Maison des sciences de l'homme, 2005).

Schmied, Wieland, *Francis Bacon: Commitment and Conflict* (Munich and New York: Prestel-Verlag, 1996).

Schreiner, Richard Gus, *The Concrete Imagination: A Perspective on Selected Works of Francis Bacon and Edvard Munch*, PhD, New York: Teacher's College, Columbia University, 1980 (Ann Arbor, University Microfilms International, 1980).

Sinclair, Andrew, *Francis Bacon: His Life and Violent Times* (London: Sinclair-Stevenson, 1993).

Sladen, Mark, *Bacon's Eye: Works on Paper Attributed to Francis Bacon from the Barry Joule Archive* (London, 2001. Published on the occasion of an exhibition held at the Barbican Art Gallery, 2001). Includes an interview with Barry Joule.

Sollers, Philippe, *Les Passions de Francis Bacon* (Paris: Éditions Gallimard, 1996).

Sylvester, David, *Looking Back at Francis Bacon* (London and New York: Thames & Hudson, 2000).

Sylvester, David, *The Brutality of Fact: Interviews with Francis Bacon* (Fourth expanded ed., London: Thames & Hudson, 2004; Barcelona: Ediciones Polígrafa, 2008).

Trucchi, Lorenza, *Francis Bacon* (Milan; Fratelli Fabbri Editori, 1975). English trans.: John Shepley (New York: Harry N. Abrams, 1975, and London: Thames & Hudson, 1976).

Wyzinska, Edyta, 'Critical reception of Francis Bacon's painting in Britain 1945-1962', MA thesis, London, Courtauld Institute of Art, 1990.

Zimmermann, J., Francis Bacon Kreuzigung: Versuch, eine gewalttätige Wirklichkeit neu zu sehen (Frankfurt-am-Main: Fischer Taschenbuch, 1986). Reprinted in 1992.

FILMS

Francis Bacon: Paintings 1944-62, film made for the Arts Council of Great Britain and Marlborough Fine Art, London, by Samaritan Films, London; concept and dir. David Thompson, music by Elizabeth Lutyens. Distributed by Gala Films. 1962/63.

Francis Bacon, produced by Alexandre Burger for Radio Télévision Suisse Romande, Geneva; dir. Pierre Koralnik, 1964.

Francis Bacon, interview with David Sylvester, BBC Television (London) for Sunday Night; dir. Michael Gill, 1966.

Francis Bacon, Grand Palais 1971, BBC Television (London) for Review; dir. and interview Gavin Millar, prod. Colin Nears, 1971.

Francis Bacon, Interview with Maurice Chapulis, dir. J. M. Berzosa for ORTF, Paris, 1971 (on the occasion of the retrospective at the Grand Palais).

Portrait of Francis Bacon, NDR Television, Hamburg; dir. Thomas Ayck, screened 1974.

Interviews with Francis Bacon by David Sylvester, Aquarius, London Weekend Television, 1975.

Fenêtre sur… peintres de notre temps: Francis Bacon, Antenne 2; interview with Michel Lancelet and Edward Behr; dir. Georges Paumier, 1977, prod. Michel Lancelet.

Regards Entendus: Francis Bacon, Antenne 2 for the Institut National de l'Audiovisuel. Text by Michel Leiris; prod. Constantin Jelenski, Bry-sur-Marne, 1983.

Francis Bacon, Drei Studien, from the series '100 Masterpieces', BBC London, WRD Cologne, RM Productions, Munich, 1983/84.

Après Hiroshima . . . Francis Bacon? Interview with Pierre Daix, Antenne 2 for Désirs des arts, ORTF, Paris; dir. Pierre-André Boutang, P. Collin; screened 5 Feburary 1984.

Die Gewalttatigkeit des Wirklichen—Francis Bacon, dir. Michael Blackwood and David Sylvester; Michael Blackwood Productions for the Saarlandischen Rundfunk, Saarbrucken, 1984.

The Brutality of Fact, interview with David Sylvester, BBC Television (London) for Arena; dir. Michael Blackwood, prod. Alan Yentob, 16 November 1984.

Francis Bacon, London Weekend Television, South Bank Show. Interview and ed. Melvyn Bragg; prod. and dir. David Hinton, 1985.

In the Name of the Father, BBC2 television documentary, for the series The Works, presented by Darian Leader; dir. David Stewart, exec. prod. Andrea Miller, 1996.

Love is the Devil, feature film directed by John Maybury. Coproduced by the British Film Institute and BBC Films, 1998; screenplay based in part on *The Gilded Gutter Life of Francis Bacon*, by Daniel Farson.

Francis Bacon: le sacré et le profane, documentary produced by Nalve Visions in conjunction with the exhibition 'Francis Bacon: le sacré et le profane' at the Musée Maillol, Paris, 2004.

Francis Bacon's Arena, dir. Adam Low; prod. BBC Arena and the Estate of Francis Bacon, 2005.